Discover Provence

Discover Provence

A Shopping, Wine,
Antiques, and Festivals Guide to
the South of France

By Georgeanne Brennan

yellow pear press

CORAL GABLES

For permission requests, please contact the publisher at:
Mango Publishing Group
2850 S Douglas Road, 2nd Floor
Coral Gables, FL 33134 USA
info@mango.bz

For special orders, quantity sales, course adoptions and corporate sales, please
email the publisher at sales@mango.bz. For trade and wholesale sales, please
contact Ingram Publisher Services at customer.service@ingramcontent.com or
+1.800.509.4887.

Discover Provence: A Shopping, Wine, Antiques, and Festivals Guide to the South
of France

Library of Congress Cataloging-in-Publication number: 2022935519
ISBN: (p) 978-1-64250-885-7 (e) 978-1-64250-886-4
BISAC category code TRV009050, TRAVEL / Europe / France

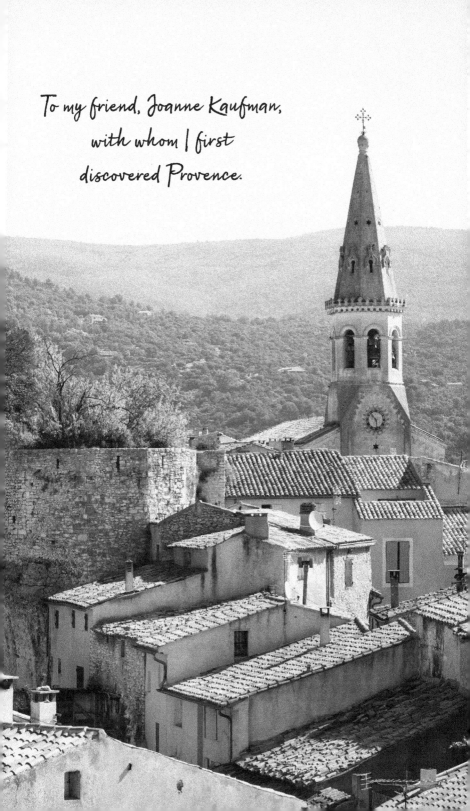

To my friend, Joanne Kaufman, with whom I first discovered Provence.

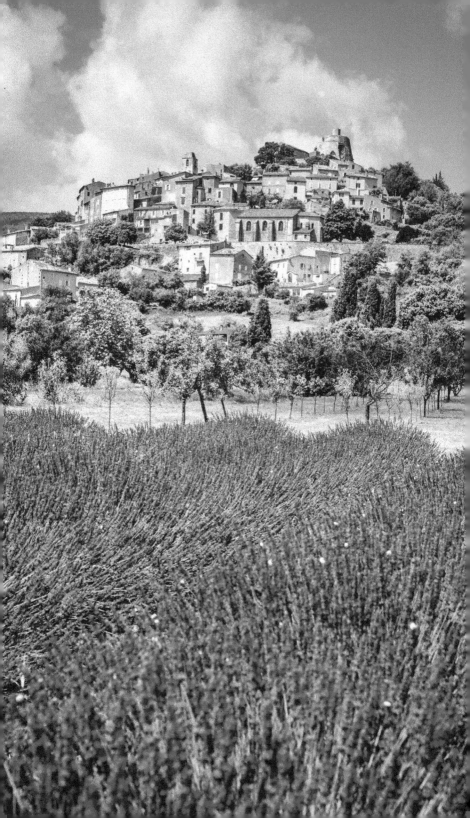

Table of Contents

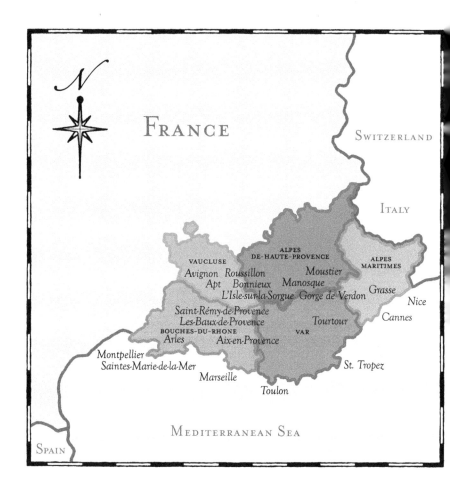

N

FRANCE

SWITZERLAND

ITALY

VAUCLUSE

ALPES
DE-HAUTE-PROVENCE

ALPES
MARITIMES

Avignon Roussillon Moustier
 Apt Bonnieux Manosque
 L'Isle-sur-la-Sorgue Gorge de Verdon Grasse
 Nice
Saint-Rémy-de-Provence Cannes
 Les-Baux-de-Provence Tourtour
BOUCHES-DU-RHONE VAR
 Arles Aix-en-Provence

Montpellier
Saintes-Marie-de-la-Mer St. Tropez
 Marseille
 Toulon

MEDITERRANEAN SEA

SPAIN

Introduction

.

I've lived in Provence on and off for many years, even buying a house there in 1970, and the region and life there has been a huge, even defining, influence on me ever since. I first encountered it as a student at the American University in Aix-en-Provence. I had requested housing in an independent apartment, and I was assigned one on the rue Aude, just a just off the Cours Mirabeau. The day I arrived, Madame Ladort, who owned the dressmaking shop next door, escorted me into the apartment. It was an eighteenth-century building with a large and beautiful interior staircase and what was to be my home was a cold-water walk-up flat on the third floor. Madame quickly showed me around and left me a key. The flat had two main rooms, one with two beds, a round dining table with chairs, and a few scattered tables. The other room was unfurnished with polished wooden floors and somewhat faded blue and gold wallpaper. The rooms had high ceilings and multipaned windows that overlooked an interior courtyard. The kitchen was outfitted with

a double gas burner set atop an ancient coal-burning stove. There was no refrigerator, and when I asked, Madame said that "one puts food that needs to be cold on the windowsill."

I had no sooner begun my inventory, slightly bemused and wondering what in the world I had done, when the apartment door swung open and in came a slim girl about my height and age. She had brown hair and green eyes and was holding a bouquet of flowers in one hand and a string bag with a *saucisson*, a *baguette*, and a bottle of wine in the other.

"Isn't this exciting?" she beamed, handing me the flowers. "We're in Provence in our very own apartment!"

I've often wondered if I would have had a different relationship to Provence, or perhaps no enduring relationship at all, had it not been for Joanne Kauffman's unabashed enthusiasm for the place and for what it promised us as young women.

And, it hasn't disappointed us, not even half a century later.

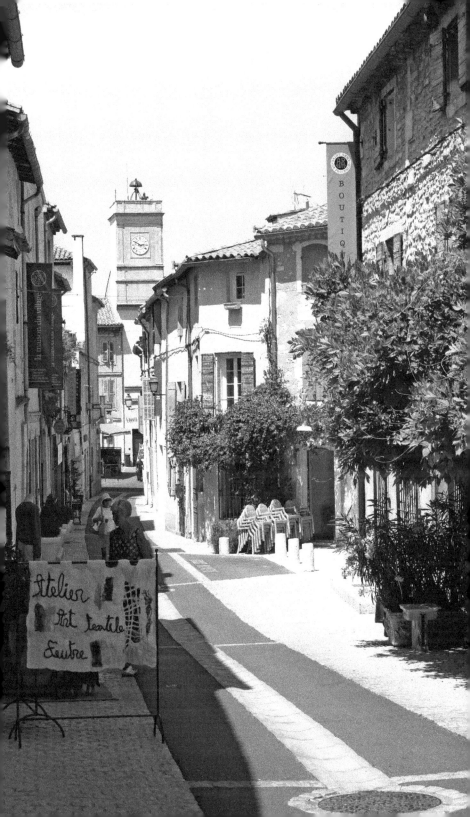

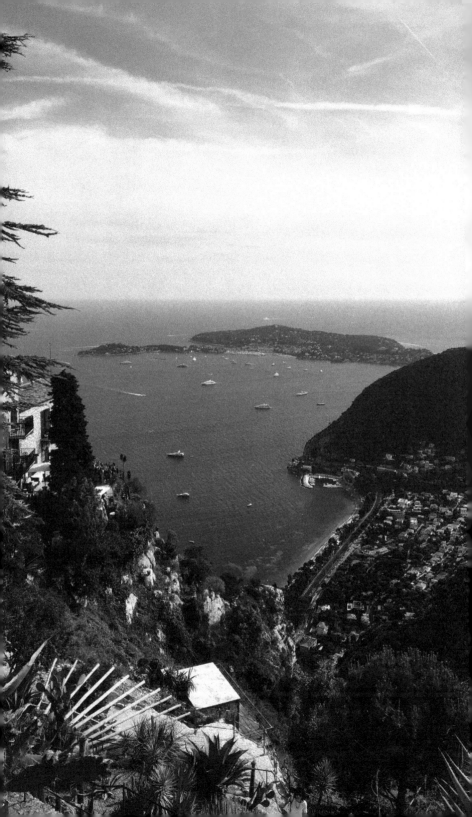

Discover Provence is a series of short essays in eleven chapters, dense with photos. In this book, I've given an overview of the special elements that make up the enduring essence of traditional Provence for me, from its diverse landscape to its food and wine, tile roofs, and patterned fabrics. Each essay is followed by a visit to a specific town or village that reflects the content of the chapter. Throughout, I've tried to present a glimpse into the heart of Provence—the small things as well as the larger ones—and all that makes it such a magical place for me and so many other people.

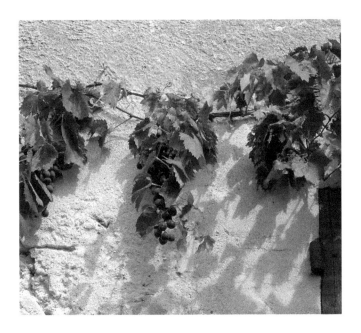

CHAPTER 1

The Taste of Provence

NOWHERE IS THE DISTINCT CHARACTER OF PROVENCE MORE CLEARLY APPARENT THAN IN ITS FOOD AND WINE. *Le terroir*—the confluence of soil, climate, and sun—is responsible for the characteristic flavors of the varied *Provençal* regions from the Mediterranean coast north to the Rhône River Valley and across to the interior highlands below the lower Alps.

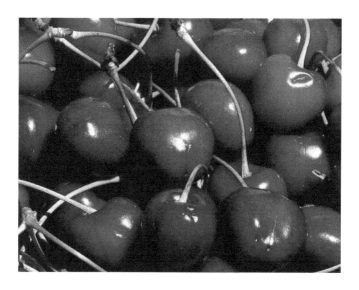

From the vineyards, groves, and orchards come grapes, olives, almonds, figs, peaches, and nectarines. The forests supply wild game, mushrooms, herbs, and black truffles, and throughout the year thousands of

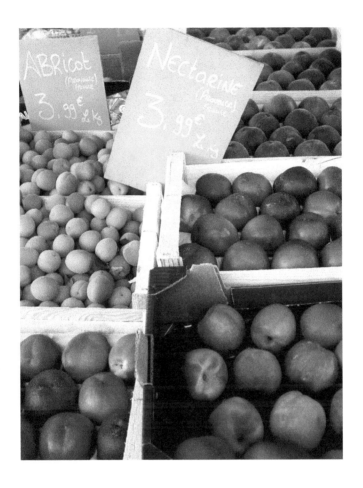

market gardens and *potagers* produce fresh, seasonal vegetables. Sheep and goats roam the rugged hillsides, feeding on the wild thyme, rosemary, juniper, and acorns that flavor both flesh and milk. Along the coast, boats bring in mussels, anchovies, sea urchins, crabs, and shop-filling arrays of fish.

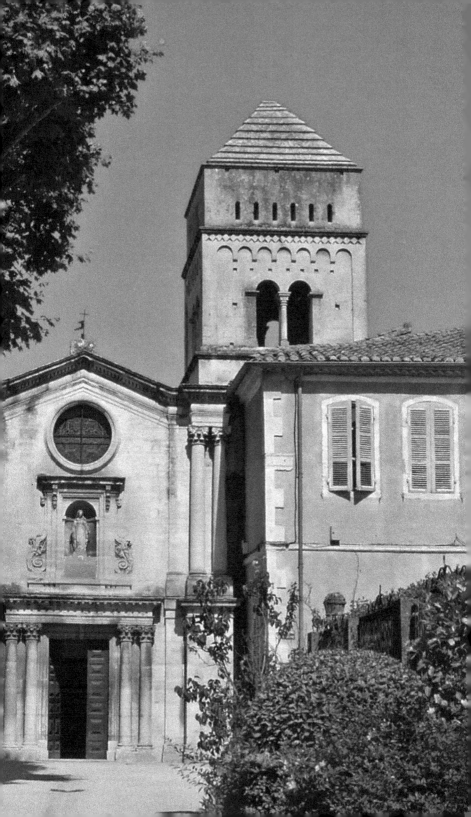

For centuries, the people of Provence have reveled in what the land and sea produce, which is reflected in their dishes, both traditional and contemporary. Along the coast, the mild climate produces a delicate, golden olive oil, perfect for poaching fish, and light, crisp wines. In the less mild interior, where summer is hotter and winter colder, are found richer olive oils, heartier wines, daubes of wild hare and boar, and desserts flavored with wild herbs. Goats' milk and sheep's milk cheeses abound—some so fresh they are sold in their molds—others spreadable, a week or so old, and older ones, hard and dry for grating.

In homes, bistros, and restaurants, the meals reflect the place and the season. Monkfish or guinea fowl baked with young artichokes and fava beans is a favorite spring dish, while summer is celebrated with unctuous gratins of tomatoes and eggplant. Fall's ripe figs and grapes—sautéed with the season's wild mushrooms— garnish the chickens and game, as well as fill crusty sweet tarts for dessert. The hallmark of winter is the black truffle. Black truffles with grilled fish, black truffles with eggs—black truffles in every possible way are served all winter. Desserts are made with fruits packed in brandy, or with almonds, chestnuts, or walnuts. The variations seem endless.

Classic foods born of old traditions have also become associated with specific *Provençal* places. The dainty, diamond-shaped almond cookies (called *calissons*) of Aix, the *bouillabaisse* of Marseille, the lamb of Sisteron, the *pan bagnat* (tuna or anchovy sandwich) and *Salade Niçoise* of Nice, and the extraordinary *fruit confit* (candied fruit), a specialty of Apt, are examples. Everywhere one goes the importance of food and of sharing meals is evident, a sure sign of being in Provence.

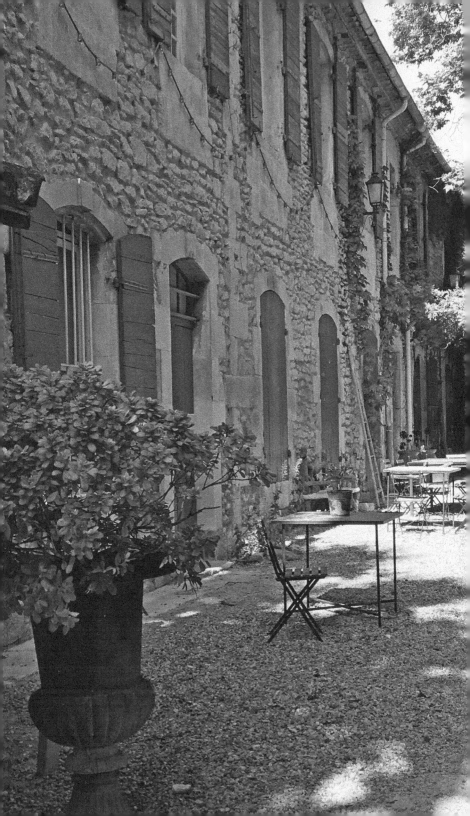

Visiting Saint-Rémy-de-Provence

Saint-Rémy-de-Provence, located in the small Apilles mountain range is in the heart of Provence. It is one of the most picturesque villages in the region with small, tree-shaded squares and streets ringed with cafés and small shops. It's protected from the Mistral—the north wind that howls down the Rhône River—and most of the year is bathed in dappled sunlight. While staying at an asylum just outside Saint-Rémy, Vincent Van Gogh, the famous impressionist artist, painted 142 paintings—many of them his most famous—depicting the landscape in and around Saint-Rémy and the village. Among them is the *Meandering Road* that captures the towering plane trees along the main road of Saint-Rémy, which still stand today. This small gem is one of those villages that feels like "old Provence," authentic in its tranquility, seemingly untouched by the twenty-first century, friendly and welcoming. Restaurants and cafés beckon, and the large open market, which runs every Wednesday from seven in the morning to one in the afternoon truly offers a taste of the region, selling everything from potted olive trees to

local honey. Just one mile from the village center are some of the most significant Roman ruins in Europe. Glanum, the historic remains of an ancient Roman city built on top of a Gallo-Greek city, is well worth a visit and paying the small fee to explore the site.

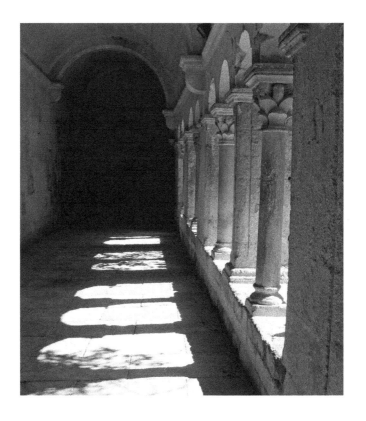

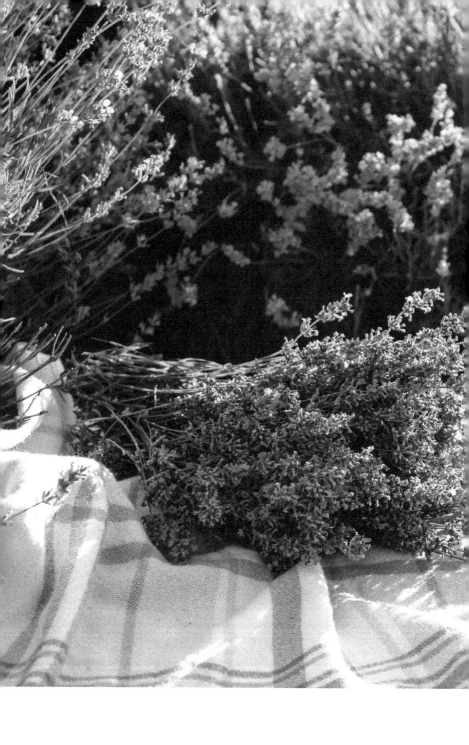

CHAPTER 2

The Wines of Provence

GRAPEVINES HAVE BEEN GROWN AND WINES PRODUCED IN PROVENCE DATING BACK AS FAR AS 600 BC, AND WINE IS DEEPLY EMBEDDED IN THE CULTURE AND DAILY LIFE. The Rhône River Valley, while part of Provence, is separated when defining the region's wines. The different regions—or appellations when discussing wine—is how the wines are designated. In Provence there are three main appellations: the Northern Rhône Valley, the Southern Rhône Valley, and the appellation simply called Provence, which encompasses all of the Provencal wine regions not included in the Rhône River Valley.

Discover Provence

Unlike many wines produced in the United States and other wine growing regions of the world, French wines are not labeled by variety, but by place. For example, Condrieu is made from Viognier grapes, but is called Condrieu rather than Viognier because that's where the vines are located.

In addition to regional appellations, wines have sub-designations called *appellations d'origine controlée*, or AOC. The designation is awarded by the French government if a particular wine is guaranteed to be of a certain quality, produced in a particular region or place under specified conditions using only specific grape varieties. Some of the appellations are well-known, like Côtes du Rhône, Châteauneuf-du-Pape, and Gigondas from the Southern Rhône, while others, like Bellet, near Nice, and Pierrevert near Manosque, are virtually unknown outside their immediate area.

There are also wines that are labeled as *Vin de Pays* rather than AOC. The *Vin de Pays* designation does not necessarily mean that the wine is of lower quality, but simply that the wine is not *guaranteed.* In fact, a

number of wine makers are producing outstanding *Vin de Pays,* so don't let the lack of designation dissuade you from trying some.

The Rhône River Valley, in particular, is noted for its wines, which are grouped as Northern Rhône, which has a cool continental climate, and Southern Rhône, which has a warmer Mediterranean climate.

The most common red grape of the Northern Rhône appellation is Syrah, but the area also grows some white grapes such as the aromatic Roussane, Marsanne, and Viognier.

Appellations from the Northern Rhône include Condrieu, which is made from Viognier grapes, and Saint-Joseph, which is a blend of Roussane and Marsanne, as well as Hermitage, which produces the red Syrah and white wines from Roussane and Marsanne.

The Southern Rhône, which produces red, white, and resé wines, is by far the larger region of the two, encompassing not only the southern banks of the Rhône River, but also the Luberon, part of Languedoc, and a

slice of the Drome. The most common red grapes are Carignan, Cinsault, Grenache, Mourvèdre, and Syrah. The main white varietals are Roussane, Marsanne, Clairette, Grenache Blanc, and Bourbelenc. Rosés are also made in the region, although the Provence appellations produce the majority of rosés.

Châteauneuf-du-Pape is perhaps the most famous appellation of the Southern Rhône, producing a red wine that is a complex blend of many different varieties, but its white wine, a blend that is predominately Grenache Blanc is also highly esteemed. Tavel, another appellation in the Southern Rhône, is unusual in that it produces only rosé, most frequently using Grenache, Mourvèdre, Syrah, and Cinsault grapes. Smaller appellations include Lirac, Rasteau, Gigondas, and the tiny Die, in the Drome.

Often when people think of wine in Provence, they think of rosé wine, which the region produces in abundance, especially across the southern portions. These are dry wines, best served chilled, and the colors can range from pale salmon to dark pink.

In Provence the varieties used to produce red and rosé wines include Cinsault, Mourvèdre, Grenache, Tibouren, Syrah, and Cabernet-Sauvignon. The white wines include Clairette, Ugni-Blanc (a.k.a. Trebbiano), Rolle (a.k.a. Vermentino), Semillon, Sauvignon Blanc, Marsanne, Rousanne, Viognier, and Chardonnay.

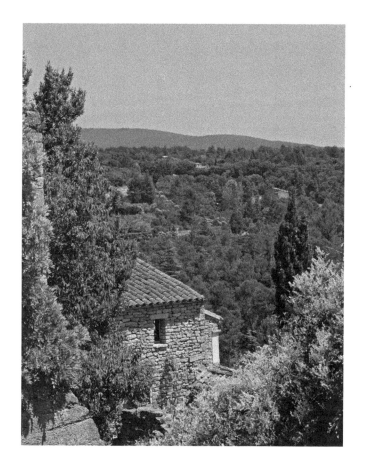

RHÔNE RIVER, NORTHERN APPELLATIONS

- Condrieu
- Saint-Joseph
- Côte Rotie
- Hermitage
- Crozes-Hermitage

RHÔNE RIVER, SOUTHERN APPELLATIONS

- Côtes du Rhône
- Côte du Rhône Village
- Châteauneuf-du-Pape
- Côtes du Luberon
- Côtes du Ventoux
- Gigondas
- Vacqueryras
- Tavel
- Lirac
- Rasteau
- Costière de Nîmes
- Beaumes-de-Venise
- Muscat-de-Beaumes-de-Venise
- Grignan-les-Ahémer
- Côtes du Vivrais
- Clairette-de-Die
- Crémant-de-Die

PROVENCE APPELLATIONS

- Côtes de Provence
- Coteaux Aix-en-Provence
- Coteaux des Baux
- Cassis
- Coteaux Varois
- Bellet
- Pierrevert
- Bandol

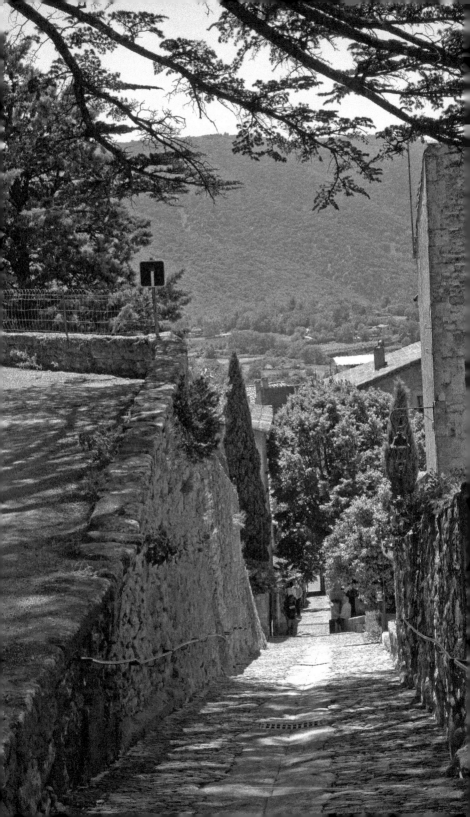

Visiting Bonnieux

The perched village of Bonnieux, is located in the Côtes du Luberon appellation east of the Rhône River. While the wines of the Luberon are not as famous (or as expensive) as some other wines in the Southern or Northern Rhône, there are a number of very good wines at reasonable prices produced there. Château la Canorgue in the valley below Bonnieux garnered notoriety when it was the set for the filming of the 2006 movie *A Good Year*, starring Russell Crowe and based on the Peter Mayle novel of the same name. Peter Mayle lived in the Luberon region, first in Ménerbes, where his adventures and misadventures there while restoring an old house are recounted in his book, *A Year in Provence*. Later he lived just outside Lourmarin, a small village where the famous French author and Nobel Laureate, Albert Camus, is buried in the village cemetery. Like other perched villages in the region, such as Loumarin, Ménerbes, and Gordes, Bonnieux is small but charming, with intimate cafés and restaurants and a history that goes back a thousand years. The villages of the Luberon have become popular places for second homes for Parisians and others, and the villages are carefully and lovingly restored.

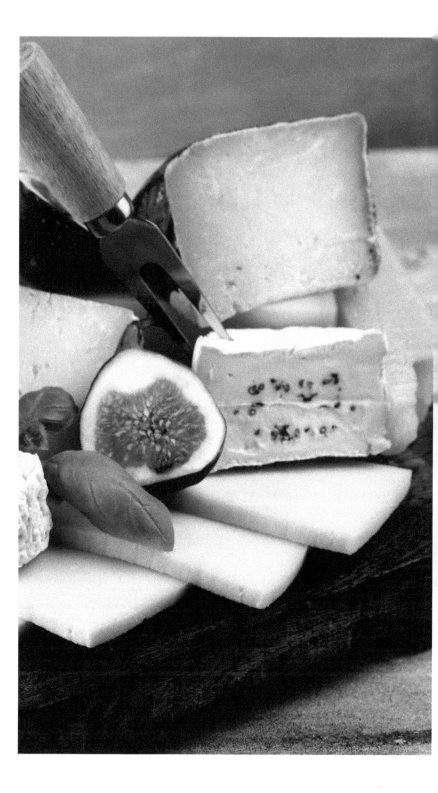

Visiting Aix-en-Provence

Aix-en-Provence is one of the most elegant cities in Provence and it is here where *The Horseman on the Roof*'s opening scene takes place. The city was founded by the Romans, and, in the Middle Ages, Aix became the home of the *Provençal* king, Good King Roi Rene and his court, and in the nineteenth century was home to both the artist Paul Cézanne and the author Émil Zola. Some of Cézanne's most iconic paintings are of the countryside around Aix, including Mont Saint Victoire—near Pablo Picasso's former home and studio—and the Château de Vauvenargues—where Picasso and his wife are buried. One of the best-known streets in Provence is the city's Cours Mirabeau, a wide boulevard lined with towering plane trees, cafés, and shops on one side, and golden-hued stone private mansions on the other. The Cours essentially runs between two districts of Aix, the old city and the newer Mazarin district. The old city has twisting medieval streets, University buildings, a series of squares where open markets are held daily, and, of course, many wine shops where one can find the celebrated wines of Provence. Many of the buildings in the spacious

Mazarin district were built during the seventeenth and eighteenth century with elaborate stone façades. Here you'll find also find the Musée Granet with a collection of sixteenth to nineteenth century paintings as well as a gallery dedicated to Cézanne's works. Both the old city and the Mazarin district are notable for their boutiques and high-quality food shops. Cafés and restaurants abound, so there are plenty of choices.

Cezanne
au pays d'Aix

FILM EN PROJECTION
PERMANENTE

UN FILM RÉALISÉ PAR ANTOINE LASSAIGNE

culturespaces

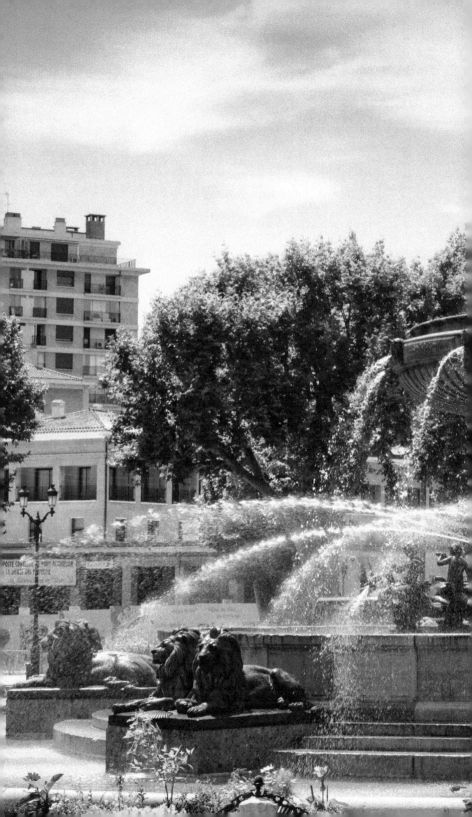

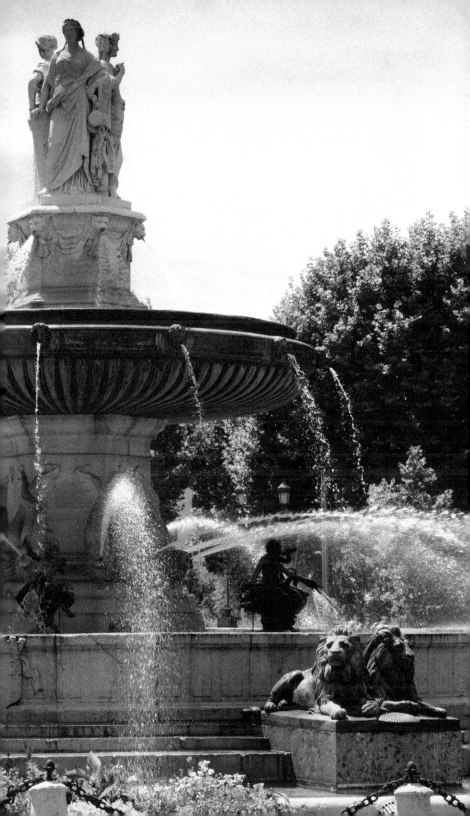

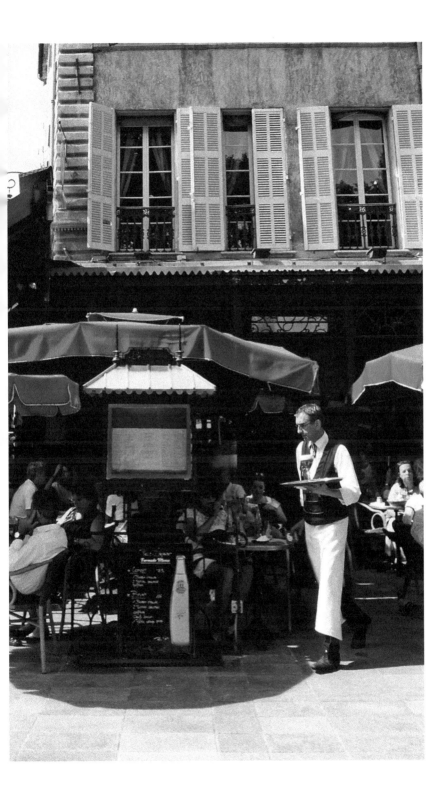

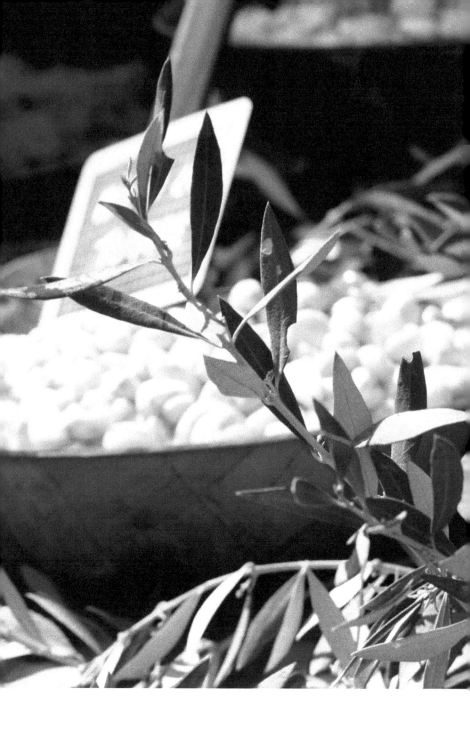

CHAPTER 3

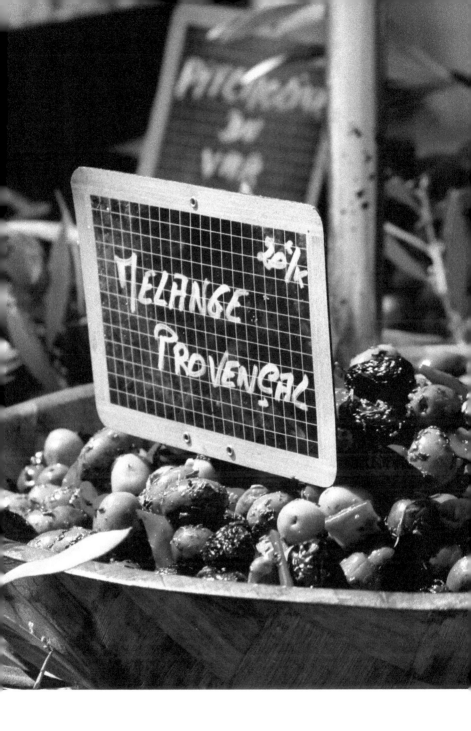

The Markets of Provence

NOWHERE IS PROVENCE MORE SEDUCTIVE THAN IN ITS OPEN-AIR FOOD MARKETS THAT APPEAR DAILY IN THE CITIES AND AT LEAST ONCE A WEEK IN EVERY VILLAGE. Vendors vie with one another to make the most enticing displays. Pyramids of plump red and white radishes tower above artfully arranged bouquets of gold squash blossoms and baskets of perfumed wild strawberries in summer, and of citrus fruits in winter. Big bundles of freshly cut spinach leaves, delicate *mâche* (salad greens), and fresh herbs engender dreams of pristine salads, while eggplants and tomatoes speak of ratatouille. Shiny-eyed fish, still slippery from the sea, are tucked into ice, surrounded with lemons and parsley and garlanded with glistening seaweed to tempt shoppers.

Cheese, charcuterie, bread, and pastries round out the food. On the periphery, the eye catches straw and wicker baskets, bolts of fabric, tools, and even clothes. Through all wafts the garlic- and herb-laden scent of chickens turning on rotisseries, of safronned paella, and spicy harissa-sauced couscous, all ready to be boxed and taken home for lunch. By 12:15 p.m., the market is beginning to close down, and by one o'clock little trace of the bustling activity remains.

In the case of the food markets, some of the vendors are the farmers themselves, bringing their own produce. Other vendors buy wholesale, then resell at retail at the market. Meat, cheese, and fish vendors may be traveling versions of a brick-and-mortar shop with a fixed location. Others may be the direct producers, especially in the case of cheese. The markets give small cheesemakers the opportunity to reach a large audience and to sell at retail prices.

Another type of market, *marché de brocante* is a sort of upscale flea market plus antiques, which are held weekly or monthly in the larger cities and towns, and elsewhere seasonally. Nice and Cannes have such markets on Monday, and L'Ile-sur-la-Sorgue on Sundays. Shoppers can wander among aisle upon aisle of tables and rugs spread with the history of Europe. Seventeenth century porcelain services for twenty sit next to single art deco plates, nineteenth century transferware, and collections of salt-and-pepper shakers. I'm drawn in by the old silver, polished to brilliancy, stacks and trunks of antique linens from long-ago trousseaus, often unused, and bolts of fabric discovered in warehouses closed and abandoned after

the Great War. Ribbons, tassels, buttons, and lengths of lace are all there at the *brocante* markets.

Often the *brocante* markets have farm and kitchen items as well as furniture of all kinds and sizes. I find the ancient farm and kitchen implements irresistible, always imagining where they might have come from and the lives of the people who handled them. Once

I was seduced by a long, hand-hewn, well-worn oak assemblage. When I asked what it was, the vendor told me it was an eighteenth-century farm tool for breaking down the fiber in flax to separate the threads before spinning and weaving. I desperately wanted it and I asked "*Combien*?" When he replied the cost was sixty euros, about sixty-five dollars at the time, I was stunned into silence, which he interpreted as hesitation and dropped the price to fifty euros. Of course I bought it. Now it sits in my kitchen, near an armchair, and I take great pleasure in running my hands over it, wondering about the previous hands that crafted it and used it.

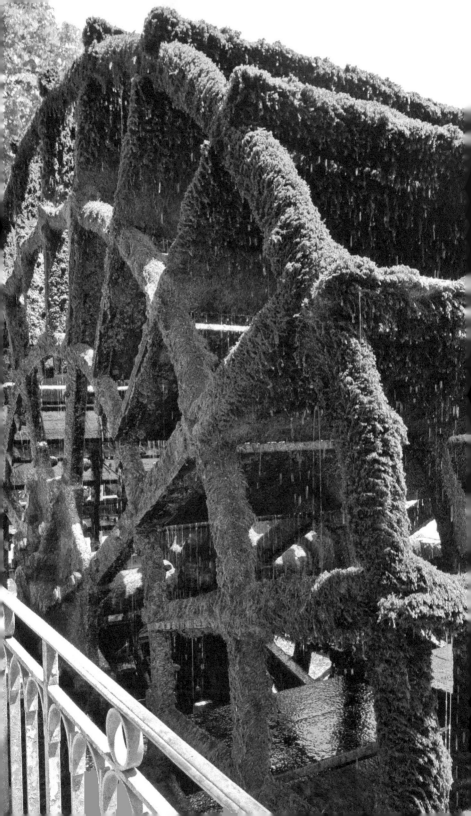

Visiting L'Isle-sur-la-Sorgue

Located only a few kilometers from Avignon, L'Isle-sur-la-Sorgue is a charming village on the River Sorgue, which rises a short distance away at the Fontaine de Vaucluse, and is surrounded by canals and waterways, constructed during the Middle Ages. The city's first inhabitants appear to have lived in houses built on stilts and made their living by fishing, an occupation which continued into the twentieth century. Today, on the third Sunday of July, a festival is held celebrating the historic fishing days. Local men give demonstrations of spearing and netting fish, and many of the inhabitants wear *Provençal* costumes. With the demise of the fishing industry came the rise of textiles. There are still the remains, some now restored, of the moss-covered waterwheels once used to power the looms of the city's silk industry, the grain mills, and other industries dependent upon power. Today, the main industry of the city is antiques, with more than three hundred permanent dealers, a number that expands to more than five hundred during the city's annual antique fairs. Every Sunday the streets along

the river and elsewhere become an outdoor market of vintage wares, filled with vendors offering items from farm tables and silver plate to buttons and linens, making the city a paradise for shoppers. There is an abundance of cafés and restaurants along the canals and waterways—perfect to rest after shopping.

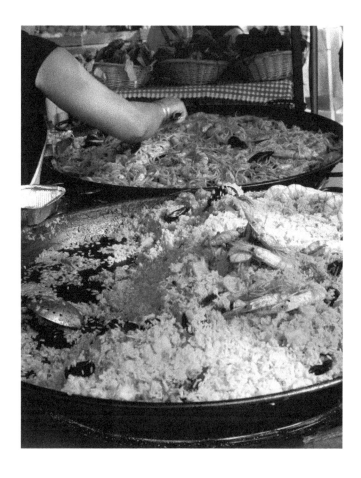

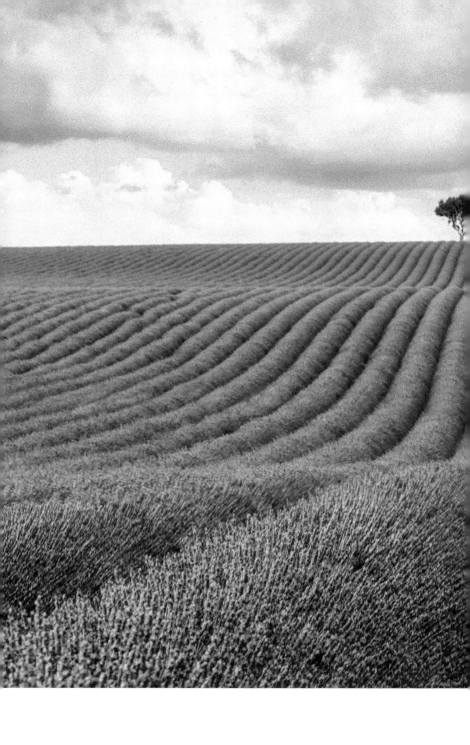

CHAPTER 4

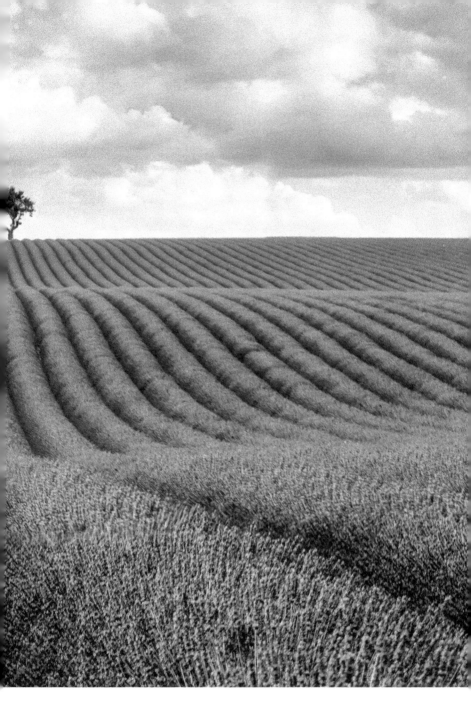

The Landscape of Provence

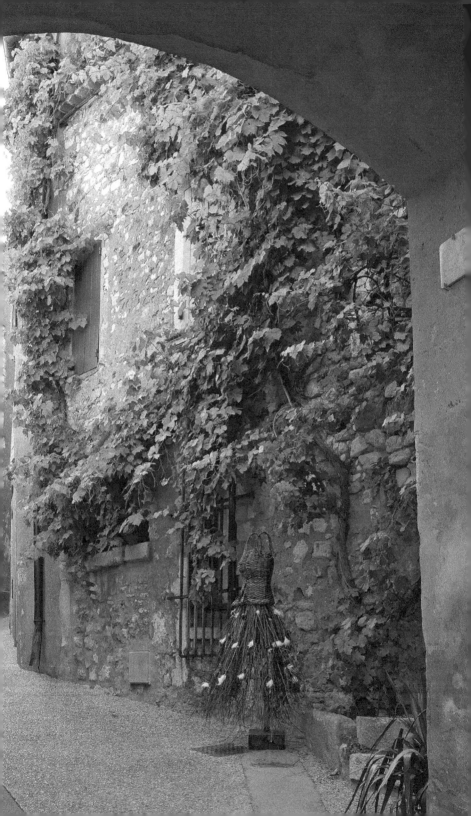

THE BOLD COLORS OF THE *PROVENÇAL* LANDSCAPE ARE ITS MOST STRIKING FEATURE. The deep blue of the sea and the sky, the varied greens of olive trees, vineyards, oak, and cypress, the red and ochre of the fields and the hills, the gray-white of limestone cliffs and quarries, and the annual bloom of lavender, sunflowers, red poppies, and wheat are the colors of the natural world. These same colors are repeated over and over again on buildings, on shutters, and on rooftops. Everywhere in Provence—whether in the flat marshlands of the Camargue in the Rhône River Delta, the rolling vineyards of Chateauneuf-du-Pape, or the Côte Rotie along the banks of the Rhône River, coastal fishing villages, the hills or mountains of the Luberon, or the narrow valleys of the interior—the striking palette of colors is reflected.

Provence has several distinct regions. There is the lush, fertile valley and delta of the Rhône River, up the river and to the east, heading into the Luberon mountains, the landscape gives way to rocky outcroppings of limestone, less fertile soil, and stingier crops, except where the Durance River, now dammed, provides irrigation. The landscape then evolves into the *maquis*—a

mixture of scrub oak, juniper, and other plants that can tolerate the poor soil, mingled with thick patches of pine forest. This is the interior of Provence, stretching from the eastern edge of the Luberon, along the spine of the Grand Canyon of the Verdon River to Annot and Entrevaux in the mountains, yet only a short distance north from Nice and the Côte d'Azur.

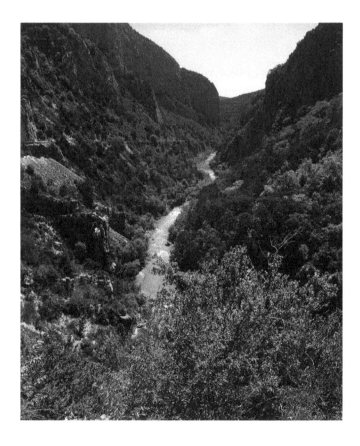

Discover Provence

From Nice, traveling west along the coast of Provence, there is a sometimes a sparse and unforgiving landscape where sheer cliffs drop to the sea, leaving only a narrow margin for a road and the occasional clustered hillside village. High tides, combined with heavy rains, can flood even the big port cities of Toulon and Marseilles, and even Nice itself.

Villages on steep coastal hills or narrow river valleys are often linear, only a few streets deep, but elsewhere they are round, set like crowns on tops of hills and mountains, built when protection from marauders, wolves, and bandits were the primary incentives for location. Some of these perched villages are listed in the official register as among the most beautiful villages of France. I love to wander in villages like Tourtour and Saint Paul-de-Vence, where the streets are often too narrow for cars, so it is easy to imagine what it was like during the Middle Ages. The building themselves are so close together that I am sure people can lean out their windows and exchange a cup of sugar or the newspaper over the flowering window boxes that seem to be a feature of every building.

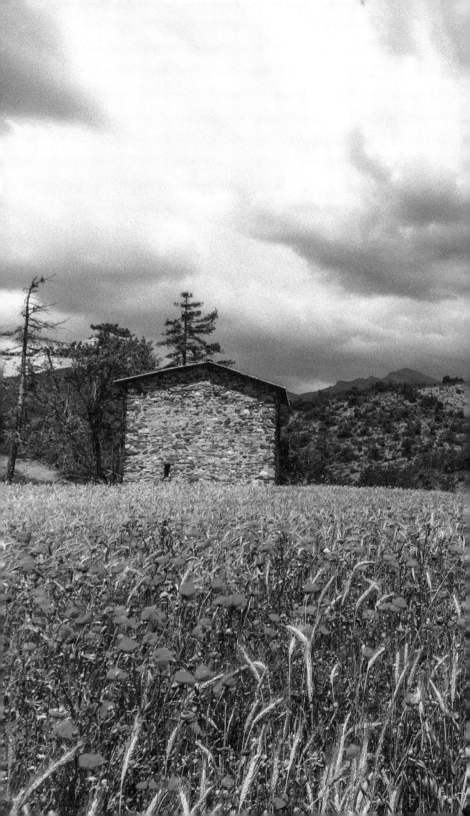

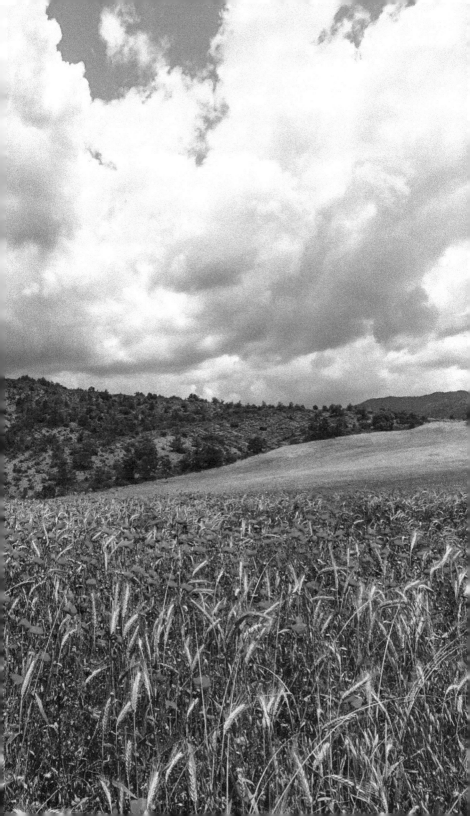

Provence is not exempt from shopping malls, *hyper-marches*, fast-food drive-throughs and the other manifestations of the late twentieth and early twenty-first centuries, and these too are now part of the landscape. Generally, they tend to be located on the outskirts of the cities and larger towns, but the empty spaces of countryside and the smaller villages seem relatively unchanged from earlier times.

Visiting Roussillon

The first thing that strikes the visitor to Roussillon is the colors of the landscape and of the village itself, situated near one of the world's largest ochre deposits. The sandy cliffs and canyons and the walls of the village buildings themselves glow with shades of rose, violet, orange, gold, yellows, and rusty reds of ochre's varied hues. Formed about 110 million years ago, the ochre deposits have been quarried for centuries; the colors extracted to be used as a natural paint pigment. The heyday of the ochre industry began in the eighteenth century, when the pigments began to be used to dye textiles in addition to coloring paint. The quarrying

continued into the early twentieth century until it was stopped in 1930 to prevent the degradation and possible destruction of what is acknowledged as one of Europe's and the world's natural wonders, known colloquially as the Colorado of Europe. For a small entrance fee, visitors can wander on marked trails in the canyon, which is surrounded by pine trees. Several shops sell pastels and paints made from the natural pigments. The village itself is formally recognized as one of the most beautiful in France, and it's worth a wander through the streets not only to shop but to admire the colors of the village houses, which, in one small space, seem to reflect all the colors of Provence.

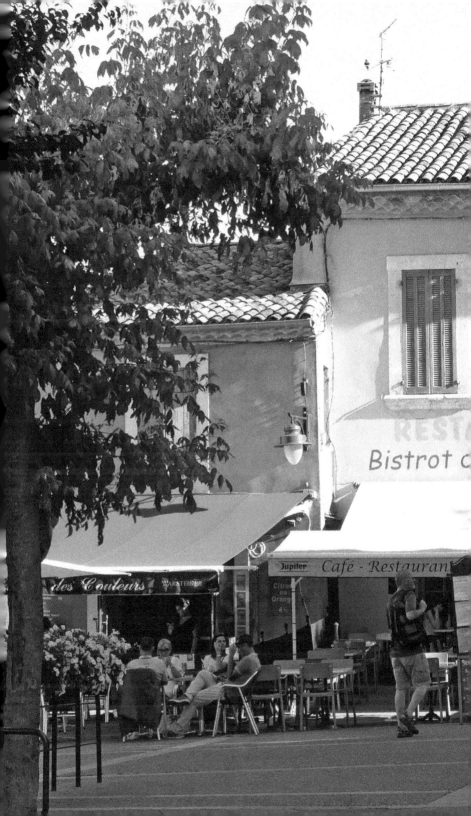

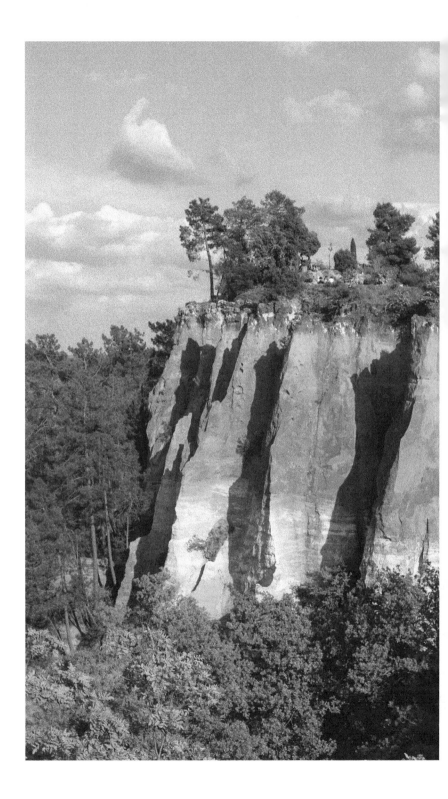

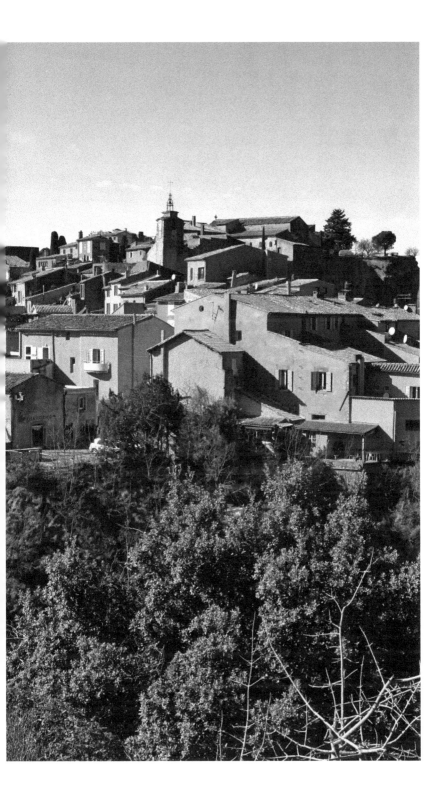

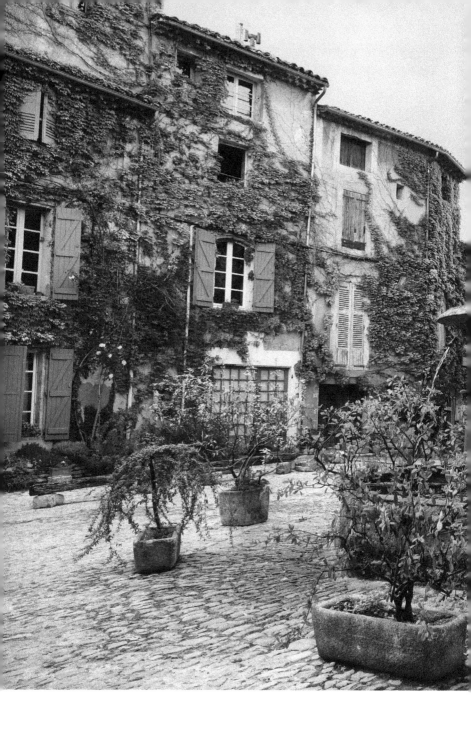

CHAPTER 5

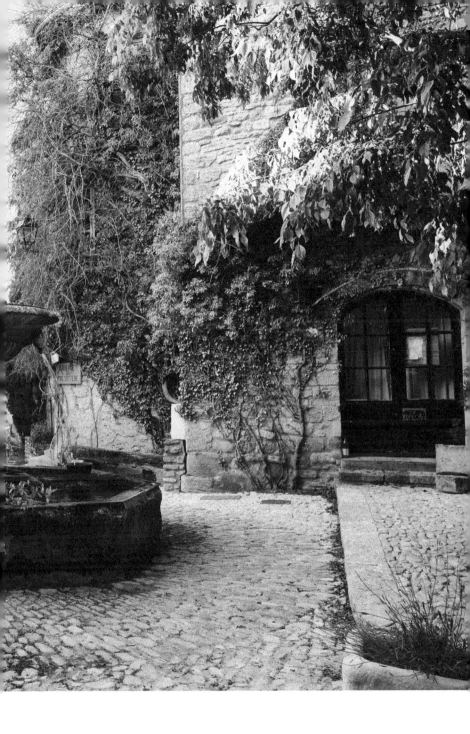

On Foot in Provence

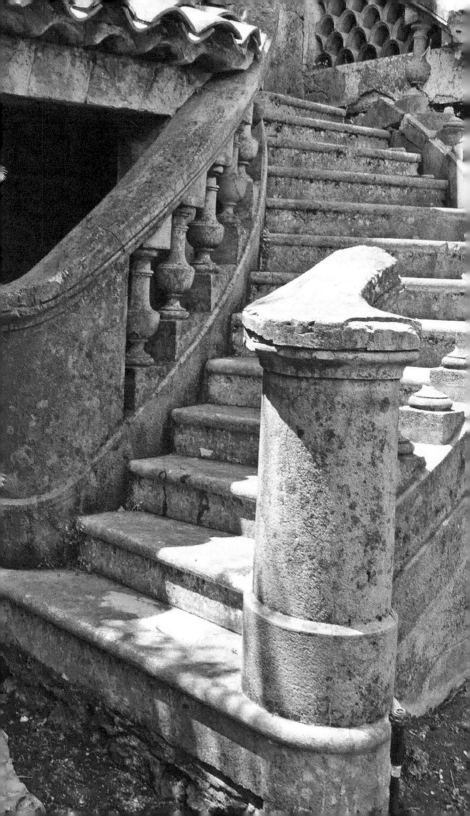

ON FOOT IS A POPULAR WAY TO SEE THE SIGHTS IN PROVENCE, AND THE *PROVENÇAUX*, LIKE OTHER FRENCH, HAVE A PASSION FOR *LES PROMENADES* AND *LES RAN-DONÉES*. Perhaps it dates back to the times of the pilgrimages when people traveled on foot to various holy sites all over Europe. Provence had—and still has—one of the major pilgrimage routes to Santiago de *Compostela*, the Via Tolarosa, or Way of Arles, which begins in Arles (see page xx), comes into Saint-Rémy-de-Provence (see page xx), and skirts the Camargue (see page xx) on its way to Toulouse. *Promenades*, unlike *randonées*, are casual walks of an hour or so, perhaps a little longer, but usually with a purpose (*promenade* also refers to any short pleasure trip, whether by car, horseback, or other means). It might be a walk around an especially beautiful village, an interesting city quarter, or, in the countryside, to visit a ruin or an old pilgrims' chapel hidden in the forest, or even perhaps to follow a meandering stream or river. *Promenades* require no particular effort or skill. Morning *promenades* are often intended to culminate with a restaurant lunch at the final destination, perhaps an especially appealing country inn or *auberge*, and the meal, of course, has been earned by walking. After-

noon *promenades*, taken after lunch, might culminate with the late afternoon ritual of coffee, tea, or beer.

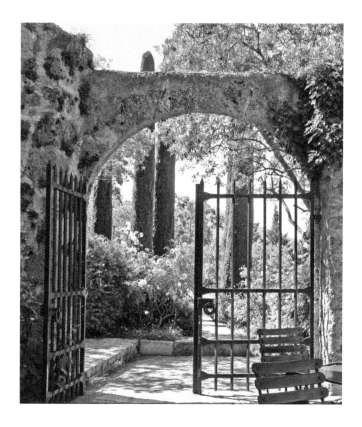

Randonnés are less casual, more directed walks, stouter and longer than promenades. *Randonnée* translates as a journey over an extended period of time, either by foot, bicycle, horseback, or even skis. Such a

trip lasts most of a day, and, often, many more. The long-distance *randonneurs* must have a certain degree of stamina to climb up and over rough terrain and to forge on in disregard of the weather. However, even though the *randonneurs* might be walking every day for several days that is not to say they have to walk all day long. Remember, this is France and leisurely mealtimes and café sitting are an essential part of life.

Some *randonneurs* use a defined system of marked public trails following paths and narrow back roads that are part of the French patrimony. Some are vestiges of old Roman roads, others the *drailes,* or tracks, used since time immemorial by shepherds and their flocks, monks, and other itinerant travelers and pilgrims. Still others are the common paths that led from medieval villages out to the neighboring fields. Whatever their origins, they were and are for public use, even when they cross over private lands.

In the 1930s, a group of French hikers and walkers, in the face of encroaching large-scale agriculture and urban growth, started a movement to maintain and preserve these systems for public use. Today, there are

three official levels of public trails: One is the *Grande Randonnées*, the long-distance collection of trails, paths, and roads that traverses the entire country, comprising over 30,000 miles. The second level is a similar collection, but it is regional, not national. The third level is a local one. Of course, these often cross one another, and sometimes share the same bit of path, much like state and country highways do.

I find one of the great virtues of the French system of paths and trails for the *randonneur* is that they frequently pass through or near villages that have comfortable inns, *chambres d'hôtes* (bed and break-fasts), restaurants, and cafés where the weary traveler can rest and be replenished. In order to hike, there is no need to tote a backpack heavy with tent, sleeping bag, and camping gear. By going village to village, a walking stick, a daypack with water, toiletries, and a change of clothes will suffice. In this sense, a *randonée* could be viewed as an extended promenade, especial-ly if you choose the less strenuous routes through flat valleys and rolling hills.

Visiting Saintes-Maries-de-la-Mer

This coastal village, located in the Rhône River delta, now part of the nature reserve of the Camargue, is notable for the Romani pilgrimage that occurs here every year on May 24 and May 25. In the time-honored tradition of pilgrims, who have been coming here for centuries, The Romani of Europe come from every corner of the continent, 10,000 strong, to join together here to celebrate their patron saint, Sarah. The village streets and the surrounding area are filled with encampments, music, and dancing. The story goes that around 40 AD, Mary Jacobe, the Virgin Mary's sister, and Mary Solome, mother of apostles John and James, washed up here after they were set adrift is a boat along with Mary Magdalene and their Egyptian servant, Sarah. In the village church, the statue of the Black Sarah, as she is called, dressed in layers of robes, is surrounded by glowing candles. During the pilgrimage, her statue is paraded into the sea by the Romani to receive a blessing by a waiting priest in a boat. *Les guardians*, or cowboys, of the Camargue, in full traditional regalia, form part of the parade,

riding into the sea as well. At other times of the year, the village of Saintes-Maries-de-la Mer welcomes vacationers and visitors to its harbor and long sandy beaches. The Camargue itself, with its salt marshes, lagoons, and grasslands, is home to flamingos, wild horses, and other wildlife as well as a large array of flora specific to the region.

Discover Provence

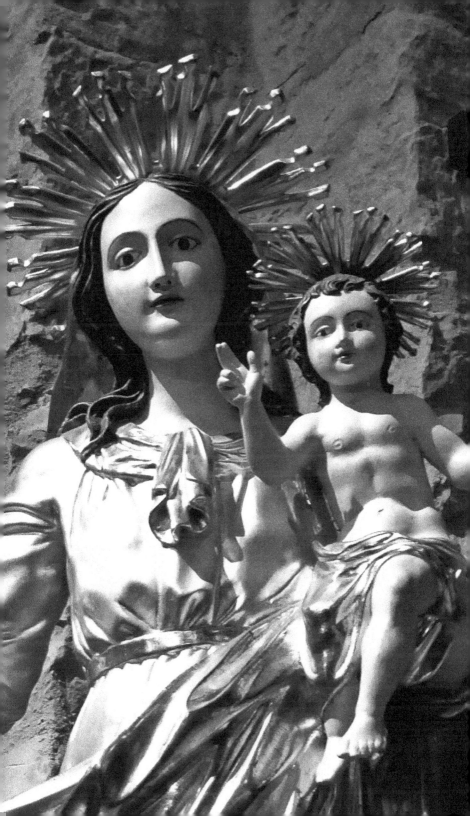

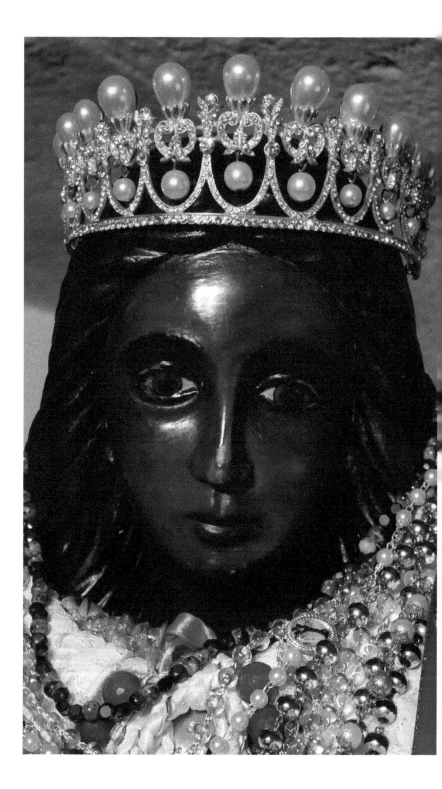

CHAPTER 6

The Scent of Provence

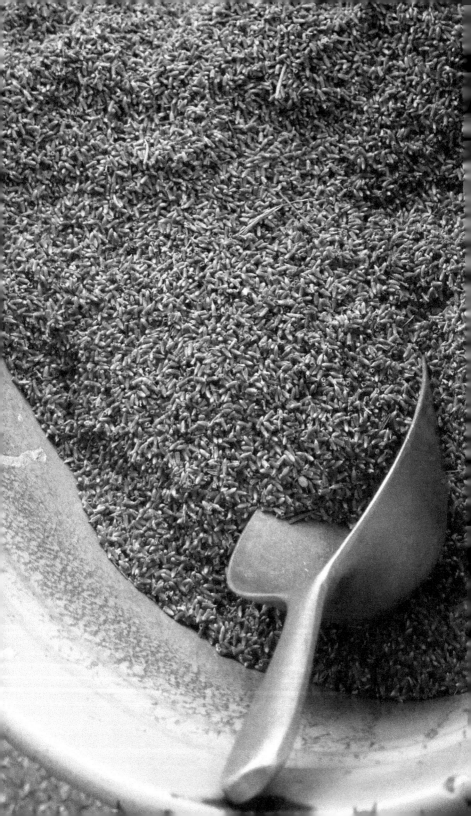

WHEN PROVENCE IS MENTIONED, THE MIND'S EYE IMME-
DIATELY FILLS WITH A VISION OF UNDULATING HILLS OF
FRAGRANT LAVENDER. It's a true vision. When the lav-
ender is blooming it seems like the fields are shimmer-
ing purple blankets and the surrounding air is laden
with the heavy scent. Passing trucks loaded with the
cut flowers trail a rich aroma behind them as they pass
through the villages on their way to the distilleries.

Lavender, which blooms from June to August, isn't the
only floral scent of Provence. Local orange blossoms,
violets, lily-of-the-valley, and jasmine, essential flo-
ral elements in perfume, grow here as well. Grasse,
inland from Nice, is the center of the huge perfume
industry that reached its peak in the 1930s. For hun-
dreds of years, fields of jasmine, lily-of-the-valley, and
violets have scented the sloping fields near Grasse,
where legions of young women picked the flowers
for the perfume houses of Gaillimard, Fragonard, and
Molinard. Here the flowers were distilled along with
orange blossoms from the Côte d'Azur and lavender
brought from Haute Provence.

Like so many local industries, the perfume business went into decline with the increased availability of inexpensive imports and modern synthetics, but has adapted. There are a number of *perfumeries* of varying sizes in Grasse, including the venerable house of Fragonard, located on a bluff overlooking the valley. Young people have returned to the area to reprise and reinvigorate family flower growing enterprises.

The herb industry of Provence is a thriving one. Thyme, rosemary, sage, oregano, lavender, and bay laurel infuse the cooking of Provence from the coast to the mountains. But while these quintessential *Provençal* herbs are culinary absolutes for the *Provençal* cook, the herbs' essential oils are also important for aromatherapy, cosmetics, and homeopathic medicine. In the nineteenth century, portable stills were taken into the fields for the distilling, but in the early part of the twentieth century, cooperative distilleries were formed, and cultivators and gatherers brought the herbs to them. Today, many of the cooperatives are closed, but the distilling continues, done in privately owned distilleries.

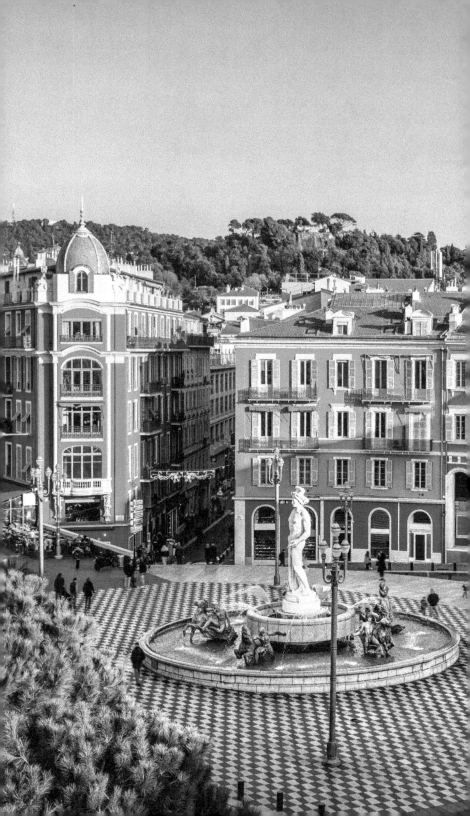

Visiting Nice

Nice, built around the generous curve of the Baie des Anges, and bordered by the Promenade des Anglais, offers a little bit of everything, from great shopping to sunbathing and museums. Sitting on the promenade, reading or simply soaking in the sun, you can watch artists painting the seascape, visitors taking in the sights, and the elderly and the young in an endless parade. In the old city, Vieux Nice, a warren of narrow streets and plazas just back from the promenade, you'll find old-fashioned wine shops where you can buy wine in bulk from barrels, or bottles of Nice's own small appellation, *Bellet* (see page xx). Garden seed shops, art stores, museums, churches, galleries, bakeries, perfume shops, cheese shops, and multitudes of restaurants and cafés are shoulder to shoulder in this part of town. Look for cafés selling *socca*, the chickpea crepes that were the traditional morning market snack for workers.

The Promenade des Anglais is lined with the grand dames of the city that date from the Belle Époque, like the Hotel Westminster and the landmark Hotel

Negresco, with sweeping staircases, cozy bars, private beaches, and a daily view of the sun setting over the sea. Restaurants are associated with each beach and are the ideal solution for a simple lunch of Salade Niçoise or grilled fish, accompanied by a crisp white or rosé wine.

But there is more to Nice that its shoreline. In Cimiez, high in the hills, you can visit the Roman ruins, the Musée Matisse, churches, and monasteries. Matisse himself is buried in Cimiez, in the cemetery near the sixteenth century Franciscan monastery.

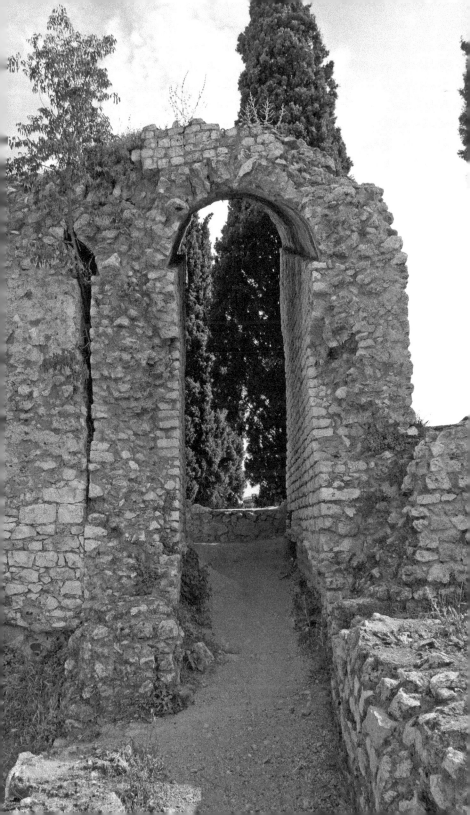

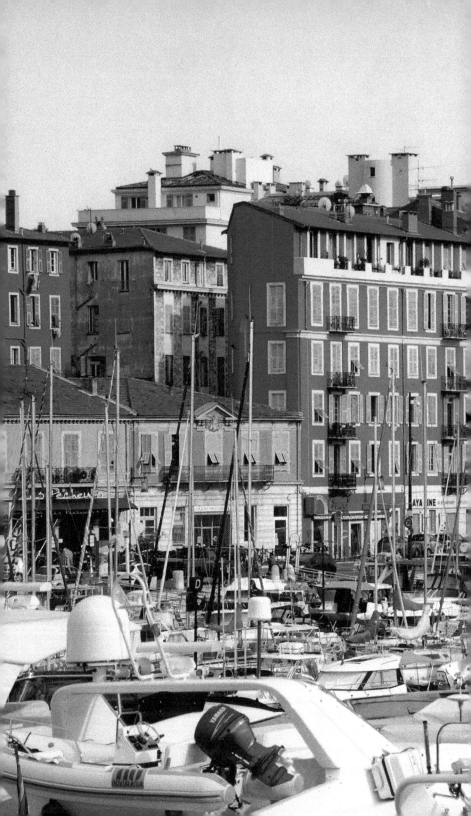

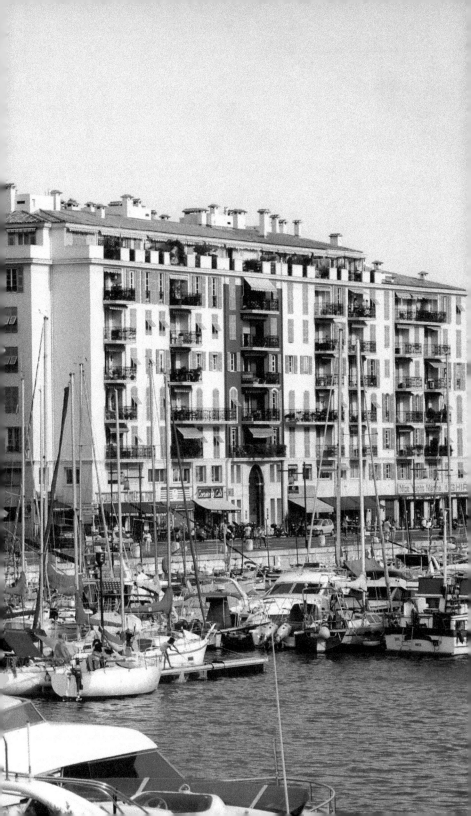

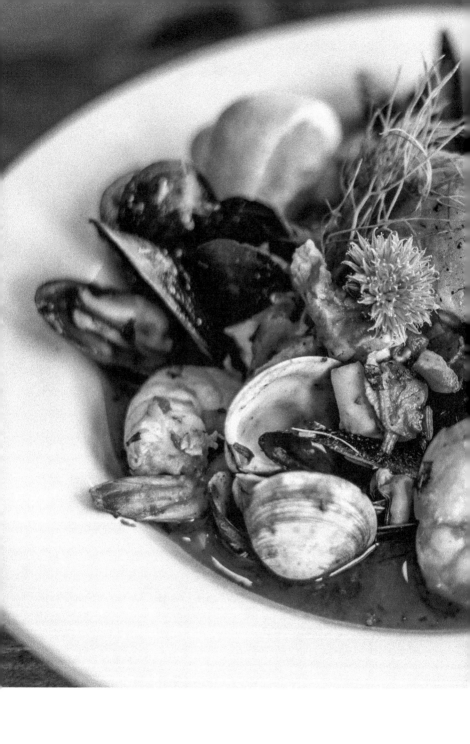

CHAPTER 7

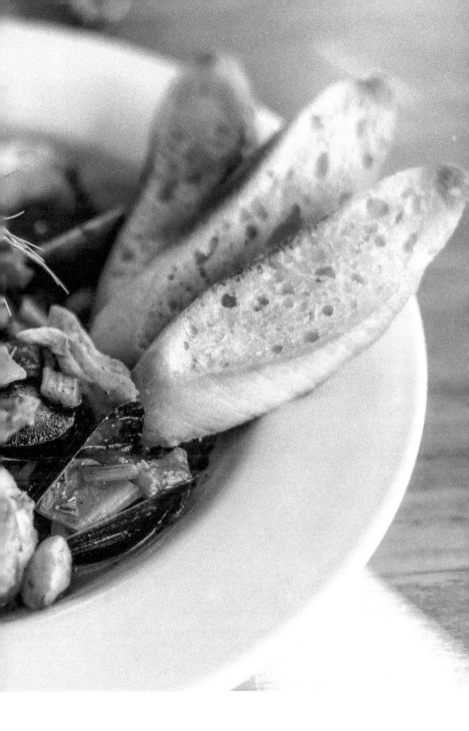

Fish Soups of Provence

BOURRIDE, BOUILLABAISSE, SOUPE DE POISSONS, AND *SOUPE DE MOULES* ARE THE GREAT FISH SOUPS OF PROVENCE. Along the coast from Marseille to Toulon each city, village, and hamlet has its own version of each of the soups, and more often than not, locals assert that their version is the true and correct one. I have seen men nearly come to fist fights over "the right way" to make a bouillabaisse or a *soupe de poissons*, each equally positive of his way and defending it to all comers.

Of course, all agree that there are some basic principles for each soup that must be adhered to.

No discussion of short-cuts, such as frozen fish, is tolerated. *Bouillabaisse* must include scorpion fish, and four or five other white fish. The large fish are cut into pieces and the smaller ones left whole. The base may be water or fish broth, but it is essential that, as the fish cook, the broth and the olive oil must come to a big, rolling boil in order to create the unctuous liaison that is the sign of a true *bouillabaisse*. In order to preserve their integrity, firm-fleshed fish must be cooked first, followed by the delicate fish. Past that, the variations

are numerous. In Toulon, potatoes are added, a heresy which appalls the Marseillaises. Traditionally, the Marseille version doesn't include mussels or clams, but you might find these elsewhere along the coast. Originally, no one would ever have included a lobster, but today, except for the purists, anything seems possible.

Bourride, no doubt because it has fewer ingredients, is less controversial than *bouillabaisse.* The distinguishing characteristic of *bourride* (see page xx) is its thick, creamy consistency, achieved by beating aioli, Provence's garlic-flavored mayonnaise, into the hot fish stock. It is essential that the *bourride* never boil, but only just simmer. If it boils, the liaison of *aïoli* (homemade garlic mayonnaise), egg yolk, and broth will be lost, the lovely creamy soup will separate, and it cannot be saved. Two or three different fish may be used, but because of its meaty texture and the gelatin of its bones, monkfish is frequently favored.

Soupe de poissons is classic fisherman's soup, made from the leftovers of the day's catch that were too small to sell. Usually these are little rockfish, tiny eels, and crabs. They are cooked whole with potatoes, fennel, garlic, onions, and tomatoes, then puréed through a food mill. The purée is poured around large slices of toasts rubbed with garlic and olive oil, then topped with a spoonful or two of *rouille* (a spicy red pepper sauce). At the *poissonneries* (fish markets) you can buy just such a collection of tiny fish, advertised as "*Soupe de poisson.*" Like *bouillabaisse,* there are the usual

adherents of you must have this and you must have that, or it will not be a "real" *soupe de poissons*. I have had a fishmonger refuse to sell me certain fish for fish soup because she said they were not the right ones. On the other hand, one of my *Provençal* neighbors makes a most respectable fish soup with river fish, adding anchovies for a taste of the sea.

Soupe de Moules is the least codified of all the *Provençal* fish soups. In some places you'll find tomatoes and onions in the soup and elsewhere the mussels will be in just a simple, delicate water-based broth. The mussels in the soup may be in or out of their shells. A recent restaurant version I had was based on a lobster-mussel *fumet* (fish stock) and saffron-infused cream finished with candied orange peel. It could be argued that this was not properly *Provençal* at all, because of the cream, but it was awfully good, and I would certainly order it again, leaving controversy aside.

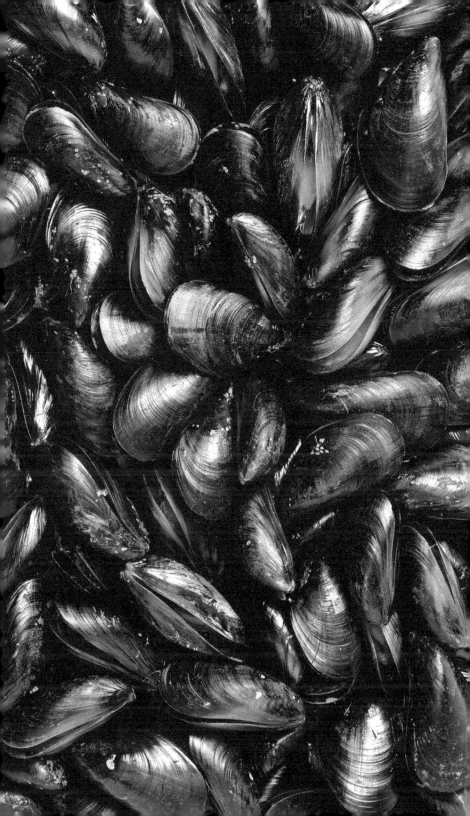

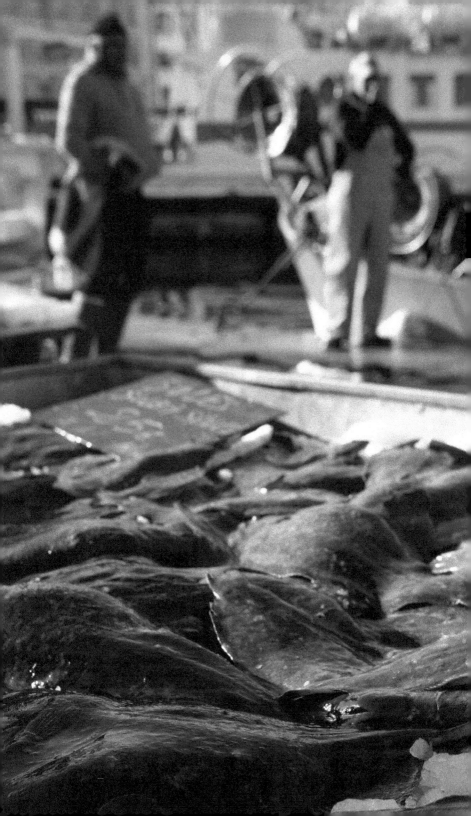

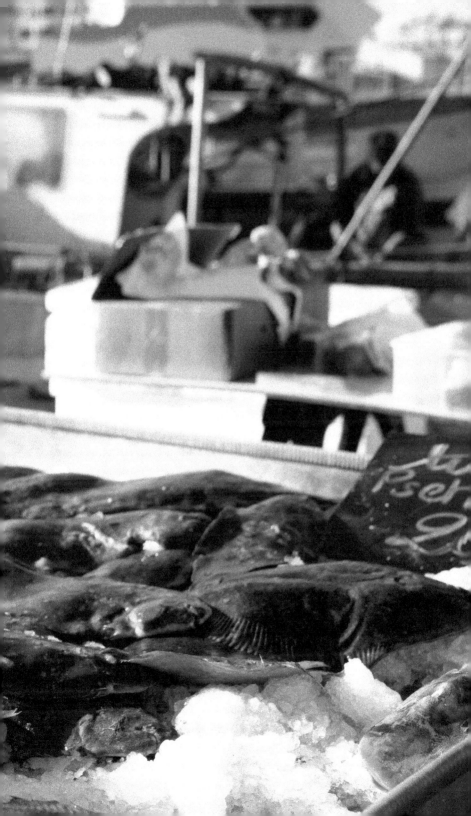

Visiting Marseille

Marseille is one of the great port cities on the Mediterranean, whose history dates back to its founding by ancient Greek mariners in 800 BC. Today, it's a diverse, vibrant city, the second largest in France with the nation's largest port. At the heart of the city's history is the Vieux Port, where the city was first founded. *Quais* (docks) surround the port, which is filled with both fishing boats and pleasure craft, and at the far end, near the Fort Saint Jean, is the new, stunningly beautiful Museum of European and Mediterranean Civilizations, which is reached by aerial walkways from the fort. Just beyond the walled harbor is the island with the Château d'If, the setting for Alexandre Dumas' famous novel, T*he Count of Monte Cristo.* Every morning, on the Quai de Belge, fishmongers line up their catch, just hours from the sea, and the scene is pure theatre, with sellers and buyers shouting alike in heavily accented Marseillaise French, and is well worth observing. Warren-like streets take you deeper into the city or high above the port to fortresses and churches, or toward the famous *calanques,* the nar-

row, steep-walled, coastal inlets that continue from Marseille east to Cassis.

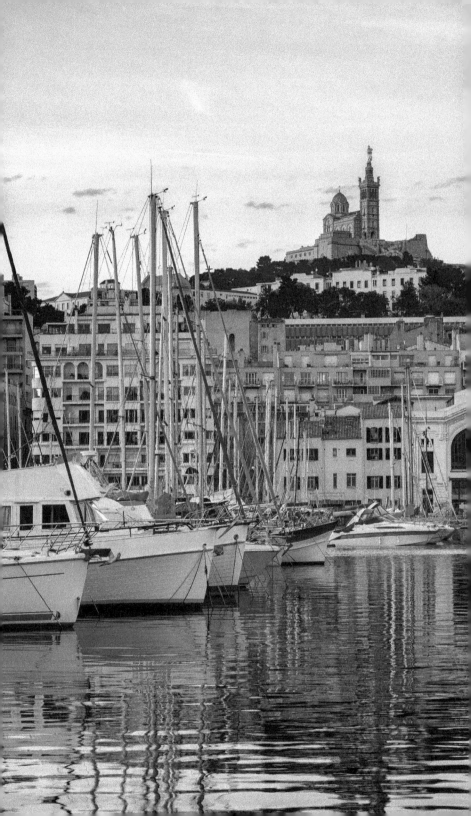

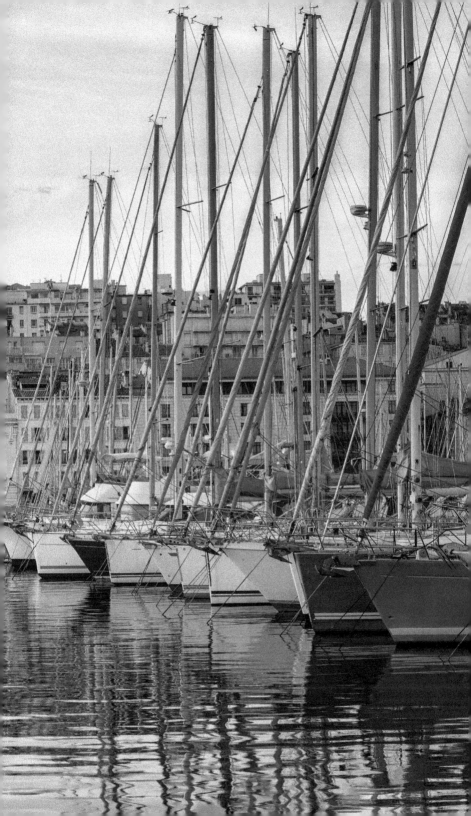

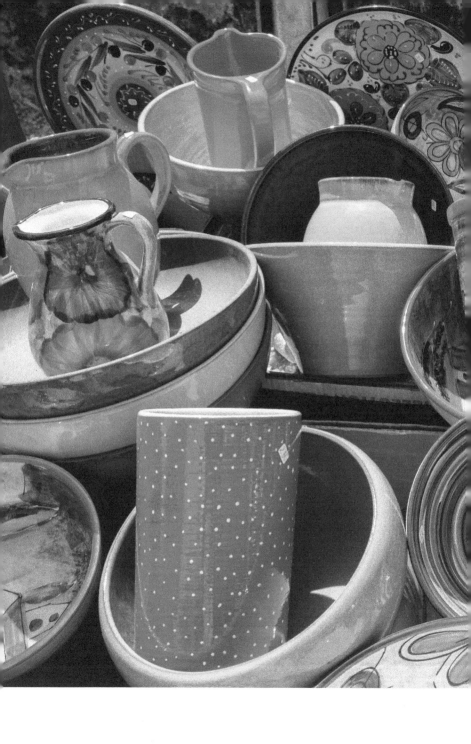

CHAPTER 8

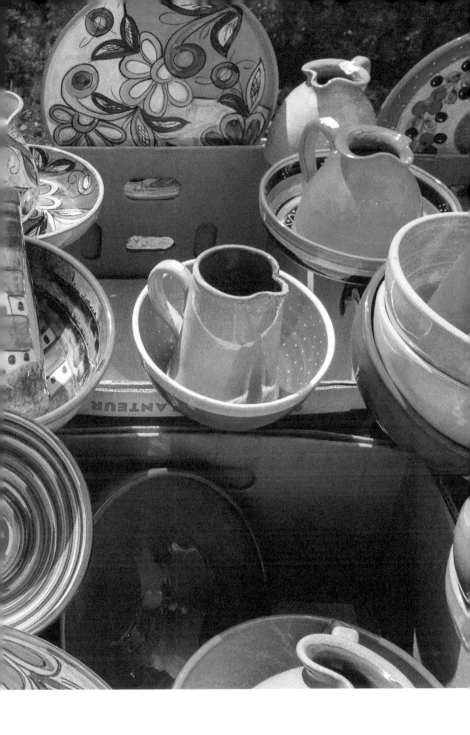

Patterns of Provence

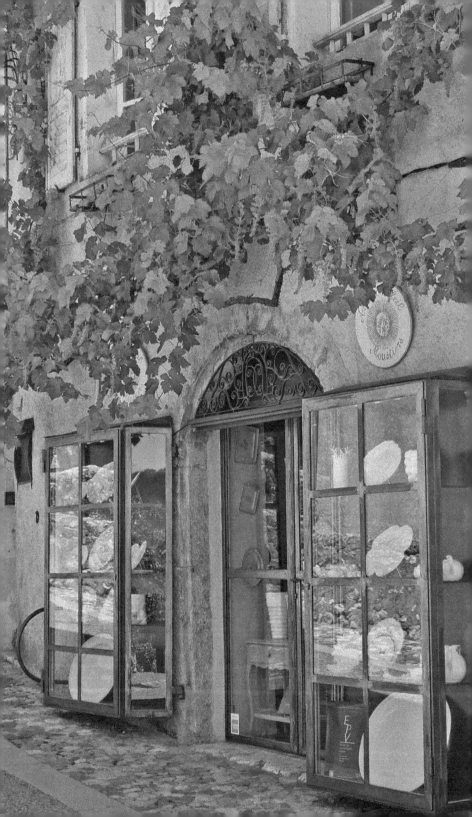

WHETHER THE POROUS, PALE, ROSE-BEIGE CLAY OF MOUSTIERS-SAINTE-MARIE THAT IS USED TO MAKE FINE DINNERWARE, OR THE DENSE, RED TERRA COTTA CLAY THAT HAS MADE FAMOUS POTTERY CENTERS OF VALLAURIS AND BIOT, CLAY IS AN ESSENTIAL ASPECT OF THE COLOR AND PATTERNS OF PROVENCE. Since Roman times, clay has been the primary material for making roof and floor tiles, as well as the vessels necessary for cooking and serving. Until the 1850s virtually every village in Provence had a potter who worked the local clay into the everyday shapes such as *marmites* (cooking pots), for long slow cooking, shallow, oval *tians* for baking, large jars for storing water, wine, olive oil and olives, molds for *patés* and cheese, and a battery of bowls, pitchers, and plates. Storage pots and cooking pots were usually glazed only on the inside, but tableware was glazed outside as well, often in decorative swirls. Today, traditional patterns are enjoying a resurgence in popularity, and once again some of the artisans are glazing their wares using the historic methods and colors.

In the latter part of the nineteenth century, more and more people moved to the cities and the need to be

supplied with pottery on a larger scale emerged. Pottery began to be mass-produced and large pottery centers developed. In the early 1900s Valluris, Biot, and Aubagne—all near growing urban population centers—had become famous pottery centers. Today, the pottery produced from these centers during the end of the nineteenth and beginning of the twentieth century are collector's items, valued for their colors and shape.

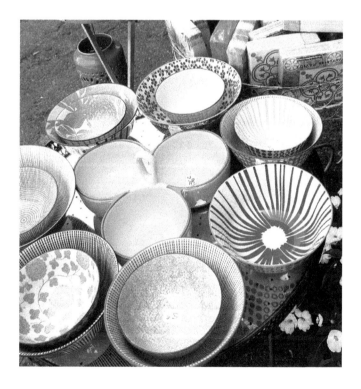

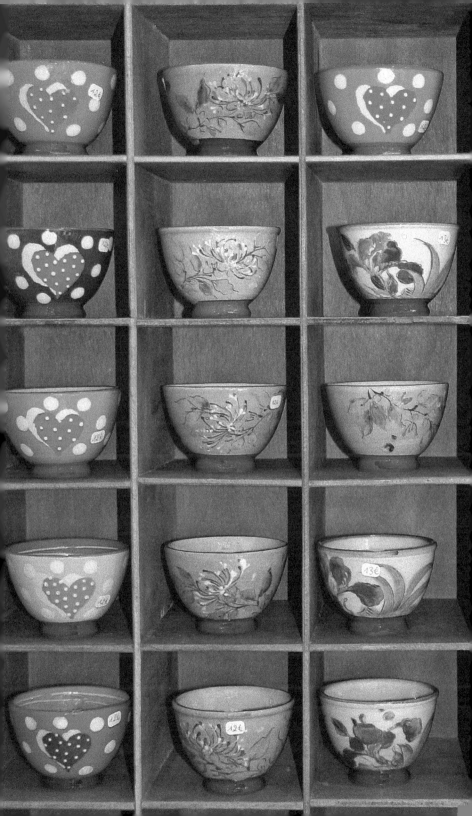

I think it is impossible to imagine Provence without a vision of tile roofs. The older tiles, like old bricks, are mottled hues and varying shades, both from weathering and from variations in the clay batch. When viewed from the vantage point of a high window or hillside the old roof tiles cast the same softened textured glow as old, worn floor tiles.

The floor tiles in the bedroom of my house are about two hundred years old, squares in shades of ochre, peach, red, and rose. The floor itself is uneven, but I resist every suggestion to redo it, because, even with the most careful handling, many of the tiles would break and could not be used again. The patina and pattern of those old tiles gives me too much pleasure to trade them up for a level surface of new tiles without a history.

There are many, many styles of terra cotta floor tiles. They can be octagons as large as two big hands, or *tomettes*, also octagon but no larger than a child's hand. They can be rectangles, small squares, large squares, or even the occasional circles. In Salernes, which has been an important tile producing areas

since the Roman era, you can still buy red terra cotta floor tiles that have been rolled by hand and cut, then baked over wood fires, the ancient way. There are also patterned tiles of cement still made in a manufacturing plant near Avignon.

The world-famous faïence of Moustiers-Sainte-Marie (glazed pottery with highly colored designs) is more akin to porcelain than to terra cotta. Although pottery has been made at Moustiers for thousands of years—the region has been inhabited for 30,000 years—it wasn't until the seventeenth century that the pottery, now known as faïence of Moustiers, started its rise to fame. The kings of France and their courtiers became enamored with the huge platters, table fountains, vases, and dinner services tin-glazed in brilliant white, hand-painted with intricate hunting and pastoral scenes or family blazons, surrounded by elaborate borders of flowers, bands of abstract motifs, lacework, flowers, and fruits. Not surprisingly, the rise in fame of the Moustiers faïence coincided with the sumptuary orders of Louis the XIV, which declared that all the silver plate of France, which included plates, platters, pictures, bowls, and serving pieces as well as candlesticks and mirrors, was to be melted down to help finance his far-flung war efforts. The king's own silver was melted, and he replaced his tableware with faïence. The kingdom followed suit, and faïence became the style, and made the fortunes of the faïence producers of Moustiers.

Hand painting the intricate patterns on the faïence was an art form in itself, and dozens of decorators were dedicated to that single task. In traditional Moustiers ware, the decoration is done the same way today as it was two hundred and more years ago. The greenware is dipped in a white glaze that dries looking like a thick dusting of powder. The designs are hand-painted directly onto the white glaze. Stenciled patterns are used to guide the decorator's hands, but only skill will keep them steady. I have tried it, and it is very difficult to do. To make the stencil, a design is drawn or copied onto a piece of transparent paper, and then the lines are closely pricked with a pin. The stencil is laid on the glazed object and fine charcoal powder is sifted onto it and thorough the holes. When the paper is removed, the design is left in outline, but disappears after painting when the piece is fired in the kiln. Stenciling the design is more easily accomplished on a flat surface than on the curved sides of a soup terrine or a pitcher.

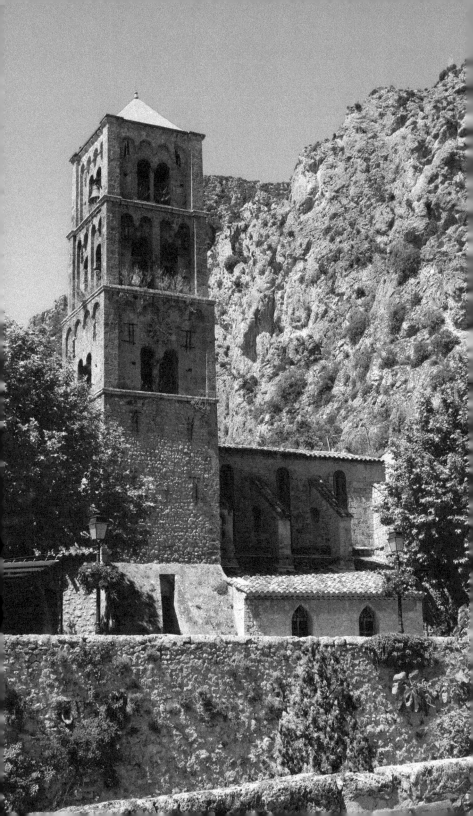

Visiting Apt

Apt, located in the heart of the Luberon Natural Park on the Calavon River, is the largest town in the area, with a population just under 12,000. Its popular Saturday market is a meeting spot for locals, many who have restored old *Provençal mas* (farmhouses) as second homes, as well as visitors from throughout the region. It is one of the most festive markets in Provence and every Saturday the streets are filled with vendors of every kind. Nevertheless, the spot remains a bit off the beaten track for many tourists and retains some of the charm of old Provence. Apt, an important fruit growing center, is widely known for its *fruits confits* (candied fruits), which are created artisanally using traditional methods. It is also well-known for its unusual ceramics, glazed in multiple layers of ribbons of color, unlike any other. The town, like many in Provence, dates back to Roman times, when Julius Caesar's armies defeated the Gallic tribes, and part of the old city walls still encircle part of the city. The most famous monument is the Cathedrale Sainte-Anne, and for this alone, Apt is worth a visit. Part Gothic, part Romanesque, the cathedral, built over several centuries,

houses, in a crypt beneath the cathedral, the bones of Sainte Anne, the Virgin Mary's mother, brought there in the first century when the town was called Julia Apta. It has been a site for pilgrims ever since and the walls are covered with *ex-votos* (objects, such small paintings, offered to fulfill a vow) as testimony.

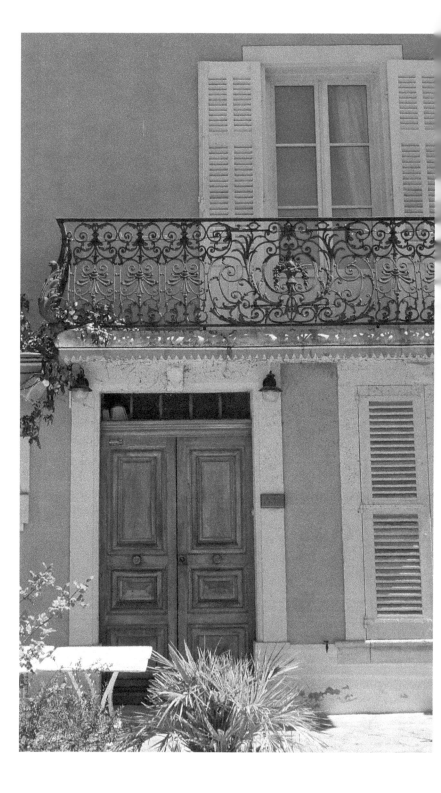

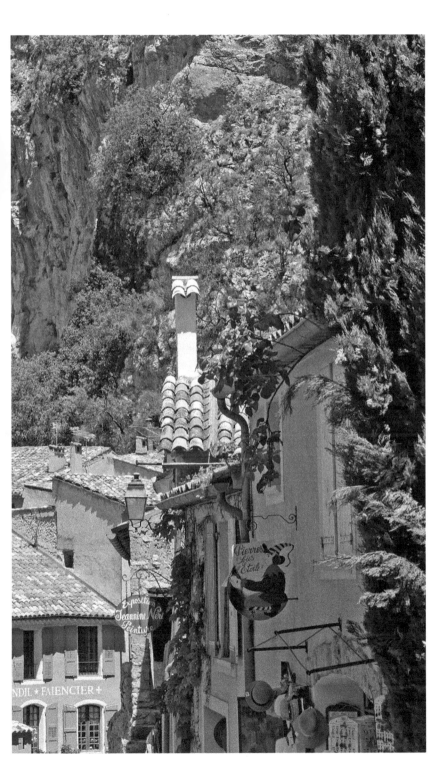

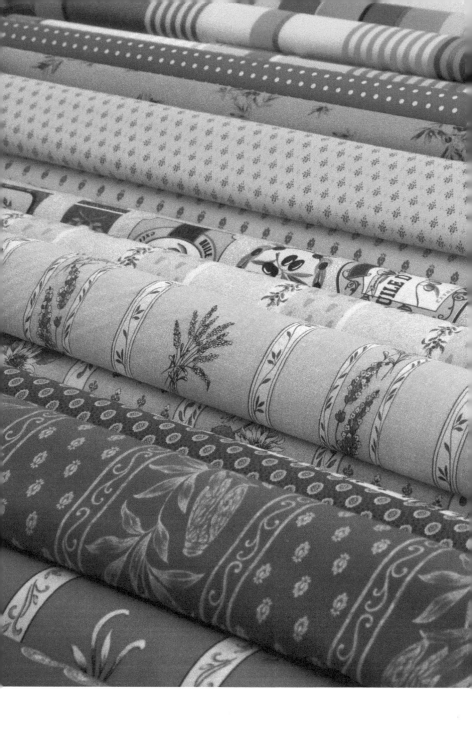

CHAPTER 9

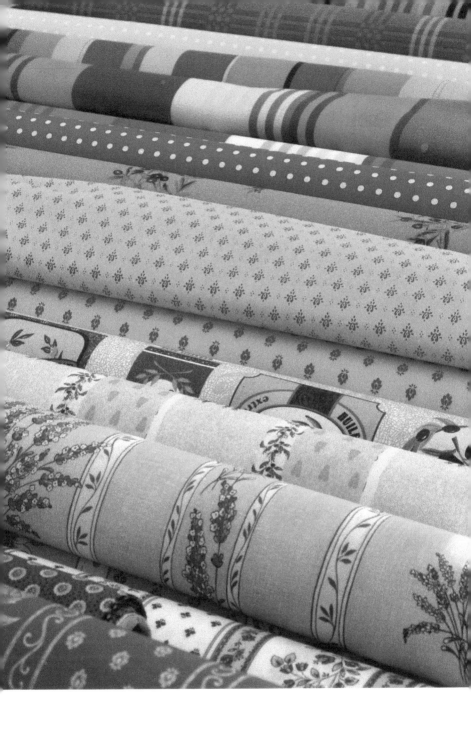

Fabrics and Textures of Provence

THE OPEN MARKETS AND SHOPS OF PROVENCE LEAVE A LASTING IMPRESSION ON THE VISITOR OF STRIKING COLORS AND INTRICATE PATTERNS. Bolts of fabric and tablecloths hang suspended from market vendors' stalls and windows, inviting you to touch them. Stacks of placemats and napkins are piled high, alongside quilts, potholders, skirts, children's dresses, baby bonnets, and bread baskets. All of them are made from cotton fabric printed in varying combinations of red, yellow, green, blue, peach, terra cotta, rose, teal, green, and white, patterned in flowered or geometric bands, circles, and paisley. Some are very simple, others complex.

Some of the traditional patterns date from the seventeenth century when merchants bought the printed cotton from Turkish manufacturers and traders and imported them through Marseilles. However, the technique for printing on fabric using carved wooden blocks originated in China more than two thousand years ago, then spread to India. The Indians were so renowned for these printed fabrics that the fabrics themselves became known as *les indiennes*, or Indian prints. The inks were made with natural dyes, of

course, the indigo plant supplying the rich blue, the red came from madder, and yellow from ochre. After being block-printed, the designs were hand-painted. Various mordents were used to fix the dyes so that the colors wouldn't fade or run. By the early seventeenth century, Turkish artisans were using the techniques mastered by the Indians. Since the Turkish cloth was less expensive than the Indian, it was the Turkish cloth that came into the bustling port of Marseilles in the 1800s.

Discover Provence

The cloth was enormously popular and became the fashion in France. This popularity inspired the intrepid *Provençaux* to set up their own workshops in Marseilles, Avignon, Tarascon, and elsewhere, imitating not only the process but the prints themselves. Some of these traditional patterns are still used today, although the manufacturing has been industrialized since the late 1880s.

Les Indiennes prints were used to make bed quilts and the quilted skirts, or *jupons piqués,* which were the traditional *Provençal* attire for women during the 1800s. The quilting technique is like the familiar American quilting: Cotton batting is placed between two pieces of fabric, and then all is attached by a series of small stitches or *piqués*, usually in a decorative pattern. This pattern may be a simple matter of diamonds or an elaborate one of swirls and curlicues. The quilts today are sometimes made by hand, but in a quirk of history, this is done sometimes in India, where labor is now cheaper than in France, and then brought back to France to be sold or exported elsewhere. Machine stitched versions, which are less fine and less expensive, are made both in France and elsewhere.

Boutis, traditionally made with white fabric, is a different technique altogether. Two pieces of cloth, without batting in between, are laid together and a pattern—usually an elaborate one—is stitched in a double band, with about a half-inch between the bands. The space between the stitching is then stuffed by threading twists of cotton yarn or cord through the serpentine pattern to make a raised design. In shops, however, you may find the term *boutis* applied to any quilt.

Visiting Arles

Arles has some of the finest remnants of Provence's Roman past, including an amphitheater in two tiers, with an arched arcade, built more than 2,000 years ago to seat 20,000 people. It is still in use for concerts, plays, and the Provencal-style bull fights where the bull is not killed. The arena sits in the heart of the city, surrounded by medieval streets, narrow buildings housing shops, restaurants, and apartments, and is only a short walk to the Alyscamps—the city's famous Roman necropolis. Another Roman building dating from the first century BC is the impressive Théâtre Antique whose façade stands guard over the busy thoroughfare of the Rue de Clôitre. But Arles, also deeply *Provençal*, is home to the famous impressionist Vincent Van Gogh, and the heart of the nineteenth century revival and preservation of the Occitan language, also called *Provençal*, and championed by the Nobel prize winning poet Frédéric Mistral. The most important *Provençal* ethnography museum, Museon Arlaten, is in Arles, started and funded by Mistral with his Nobel prize money. The people of Arles, especially the women, are noted for their *Provençal* dress, which

is still worn today on holidays and in parades, most notably the first Sunday in July, where the streets are filled with costumed inhabitants.

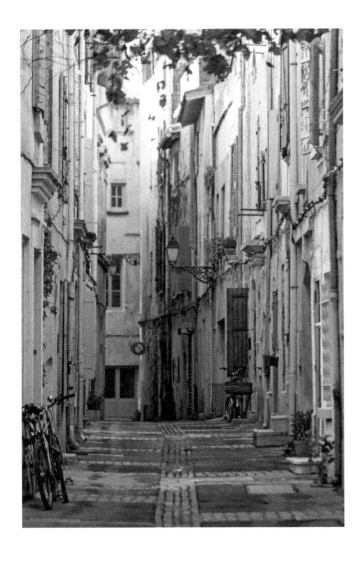

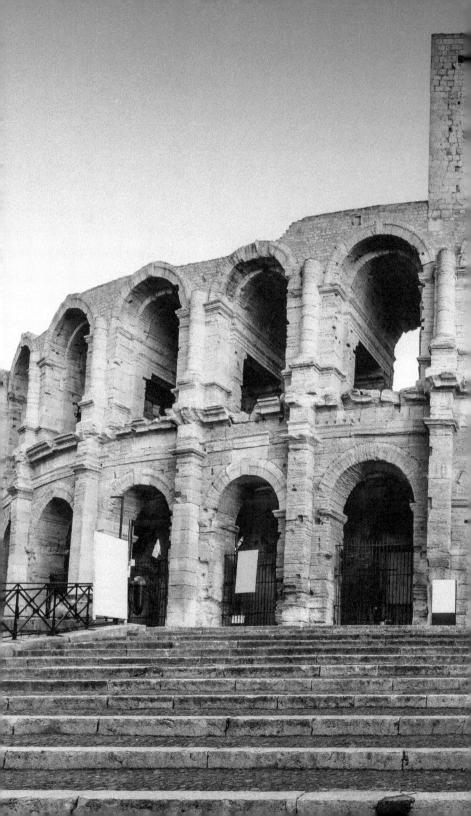

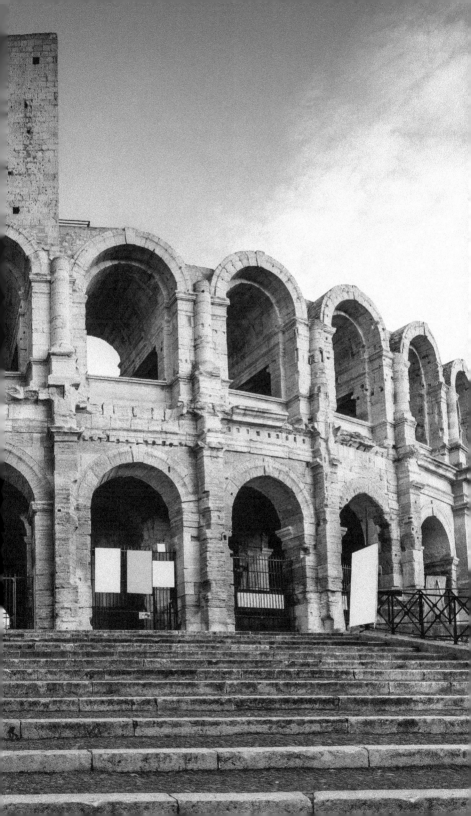

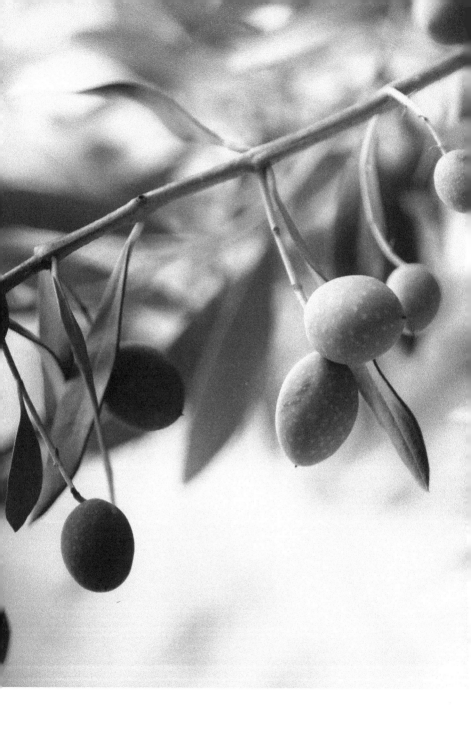

CHAPTER 10

The Seasons of Provence

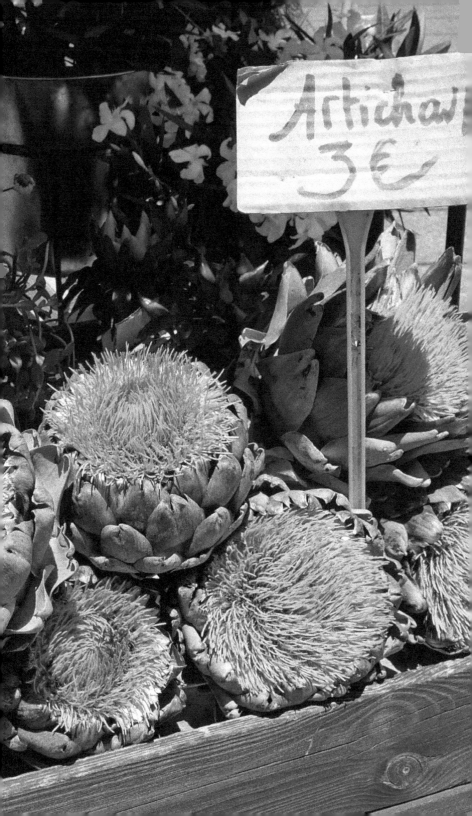

EACH SEASON BRINGS SPECIAL TRADITIONS AND CU-LINARY TREATS TO PROVENCE AND ARE CELEBRATED WITH ENTHUSIASM AND PARTICIPATION. In spring, it's time to gather wild asparagus and leeks, morel mushrooms, wild strawberries and cherries, and to cook tender young artichokes and fava beans. Soon the wild thyme is blooming, carpeting the land with purple blossoms that are gathered by the basketful to make bottles of thyme liqueur. At Easter time, lamb or kid is a centerpiece of the holiday meal. During the Lenten carnivals, baskets and baskets of *bugnes* (a special Lenten cookie coated with powdered sugar) are passed among the celebrants.

Summer is the season of the fresh garlic harvest, so it is logical that on August 15, the Feast of the Assumption, *aïoli*, the *Provençal* mayonnaise, is the focal point of *le grand aïoli* feasts that are held all over Provence. Summer brings endless melons, like the Charentais and the Cavaillon, and ratatouille, made with tomatoes, eggplant, zucchini, and peppers. The grass in the mountains is plentiful, the dairy stock are flush with milk, and the local cheese makers are churning out cheeses, so it is not surprising that the cheese platters at meals' end are sumptuous.

Come fall, the figs hang sweet and heavy on the limbs, and come into full flush. The markets start to fill with the burnished copper Musquée de Provence pumpkins, then freshly harvested chestnuts, walnuts, and almonds. But the best thing about fall is, after the first rains, the wild mushrooms. Wild mushrooms appear on all the restaurants menus and family tables throughout Provence from the time the season begins in October until the frosts end it in November.

Discover Provence

The *Provençaux* are resigned to the end of mushroom season because that means that winter's truffle season is soon at hand. From the official opening date of truffle season at the end of November until it ends in late February, truffles are the reigning culinary obsession. Unlike mushrooms, they grow completely underground, and it requires skilled dogs or pigs to find them. Everyone wants to eat them, but they are often available at certain *marchés* (open-air markets), at festivals, specialty markets, through a friend, or a friend-of-a-friend. Winter is also hunting season, and wild boar, pheasant, woodcock, and *grives* (small game birds) are an important part of life. About the only day of the week you won't see hunters is on Wednesday because the French government decreed no hunting on that weekly school holiday, so parents and children could walk safely in the woods and forests.

Winter's biggest holiday is Christmas and everywhere in churches and in homes, people set up their *Provençal Crèches*, populated with local figures. Some families still prepare the traditional Christmas Eve *gros souper*—a meal of seven to ten special dishes and thirteen dif-

ferent desserts. For New Year's Eve one finds oysters, champagne, and truffles are *de rigueur*. Many villages celebrate Saint Blaise on February 3, where the tradition is to go from house to house, singing and then being served food and drink. Barjols, a small town in the Var, is just one of hundreds of villages in Provence that has its own local *fête*, or celebration. Every four years, the people of Barjols celebrate Saint Marcel on the 16th of January in honor of the town's patron saint. For two days the town gives over to singing, dancing, and celebrating the holiday, which culminates with a whole ox being roasted in the square.

Part of the charm of Provence is the huge variation among the villages, towns, and cities, each with its own character, and special occasions, and yet all are linked by a shared enthusiasm for their seasonal activities and foods. In fall, anywhere in Provence, people readily discuss the mushrooms; in summer the quality of the melons or the best *aïoli*. Come winter, the talk in the cafés and at the village post office or pharmacy is about truffles; and in spring, it turns to wild asparagus and greens.

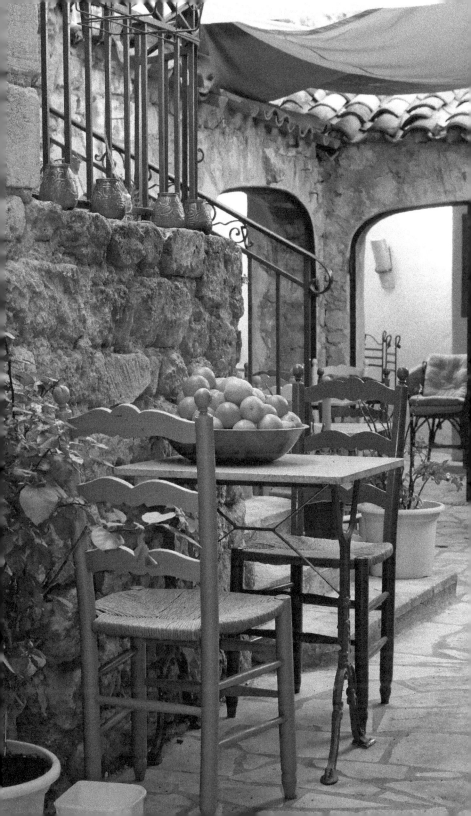

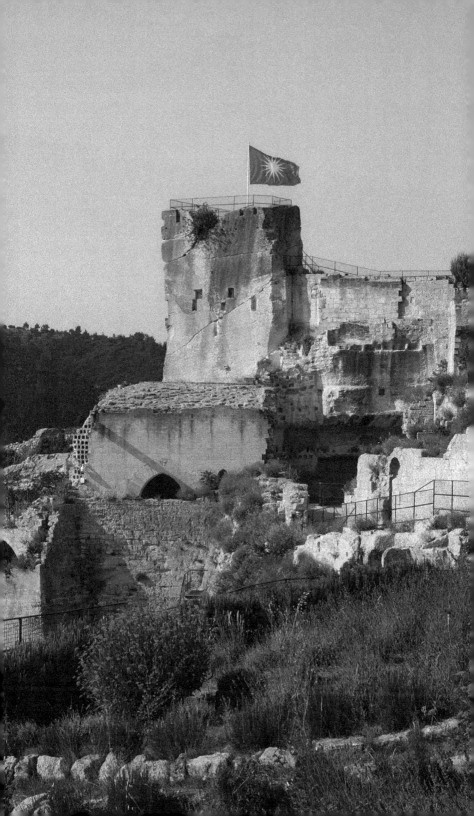

Visiting Les-Baux-de-Provence

The once-powerful Lords of Les Baux, known as the "Race of Eagles," built a fortified castle on the isolated rock spur of Les Baux in the Alpille Mountains not far from Arles. For centuries the fortress dominated the valley below and made the site impregnable. Although they were warriors, the Lords of Les Baux were also noted throughout Europe for their Court of Love and their troubadours. Today the remains of the castle, built in the thirteenth and fourteenth centuries on the remains of a tenth century fort, tower above the peaceful vineyards and olive groves in the valley below. It is both a romantic and mysterious experience to wander among the ruins, in and out of the partially standing rooms, and to climb staircases to nowhere, especially on a day when the Mistral wind is howling, whistling in and out of the stones. You can almost hear the songs of the troubadours and see the sweep of the courtly life. At the base of the castle ruins, you'll find the contemporary village with galleries, cafés, and artisans, and even a workshop where *santons* (the *Provençal* figures for the crèche) are crafted. Les Baux

is famous today for its "living crèche," part of midnight mass on Christmas Eve, where villagers are dressed in costumes and a lamb is offered in the church, a gift to the new-born Christ child from the shepherds.

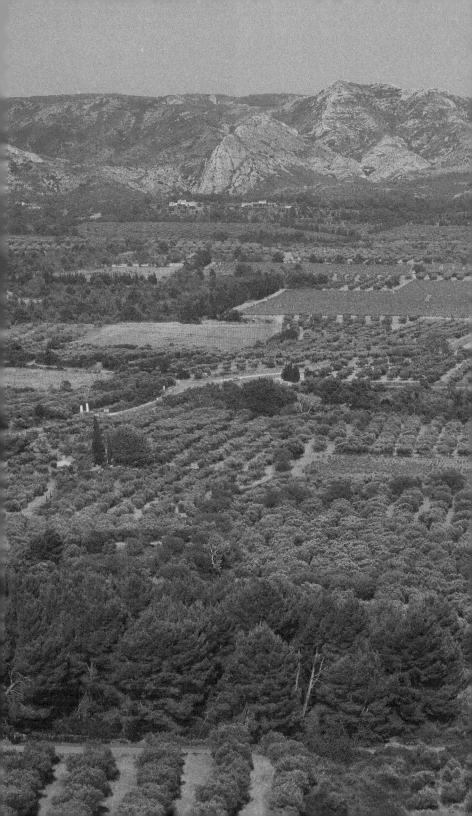

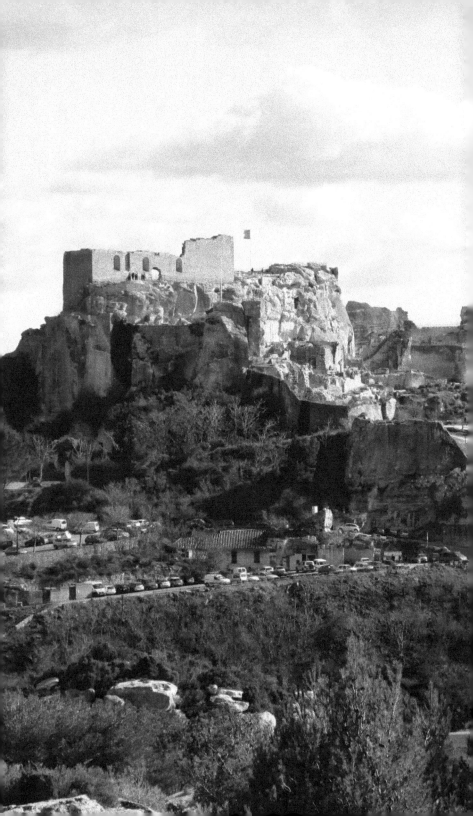

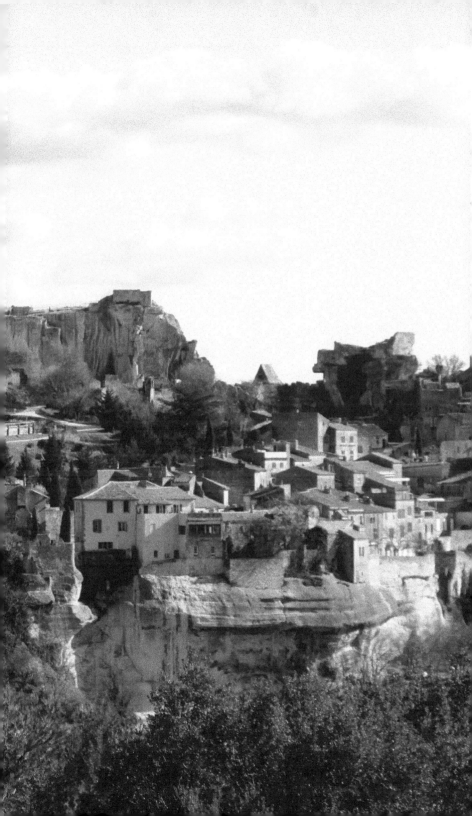

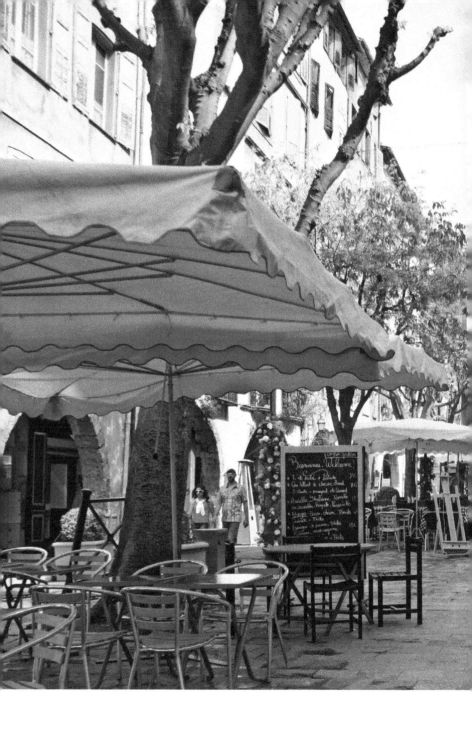

CHAPTER 11

Café Culture of Provence

CAFÉS ARE THE HUB OF SOCIAL LIFE IN PROVENCE. Each café is a revolving show with the players changing with the times of day, the seasons, and the weather. Regardless of age, gender, or walk of life, everyone finds something to bring them to a café at least once a day. Maybe it is just to get an espresso or a pastis, but it might also be to play cards, meet friends, catch up on the local gossip, discuss politics, or simply to relax and watch the world go by. The drinks provide the *raison d'être*.

Behind every café counter the bar displays dozens of bottles of *apéritifs* and *digestifs,* cognac side-by-side with bourbon and whisky. Nestled on one end of the bar is the all-important espresso machine. The counter itself, whether old-fashioned zinc, polished wood, or marble, typically has a row of draft beer handles, ready to supply a glass of foam-topped *pression.*

In the morning, some, but not all, cafés offer croissants, bread, butter, and *confiture* (fruit preserves) and at lunch a selection of sandwiches, usually made with a half a baguette loaf and filled with ham, pâté, or sometimes *rillettes* (spreadable meat paste) are

available for those wanting a bite. In the more elegant cafés, olives and potato chips may be offered with drinks, and, in a diminishing few of the country cafés, old-fashioned peanut vending machines sell, for a few cents and a turn of the handle, a dish of salty peanuts. But the simple sparse fare offered in *Provençal* cafés is not the star of café life: The drinks are what draw people into the cafés throughout the day.

The *habitués* vary with the time of day. In the very early morning, bankers, masons, secretaries, and schoolteachers rub elbows over espresso, café au lait, even a cold beer, or for some, a wake-up pastis or brandy. A little later in the morning, you'll find women meeting before or after shopping, students reading or writing in notebooks, and salespeople in between calls, stopping for a morning coffee. By midday the crowd has changed again. People are meeting for an *apéritif* before lunch, ordering pastis, beer, wine, or nonalcoholic drinks like tomato juice or *menthe a l'eau* (water with mint syrup added). An hour later, the café is quiet again except for perhaps a few retired men playing their daily card games. Then afternoon coffees gradually blend into the dinner-hour *apéritifs*.

On market days, especially in warm weather, after loading their baskets with breads and cheeses, meats, olives, fresh fruits, and vegetables, everyone fans out to the cafés. The tables are jammed and the conversation spirited.

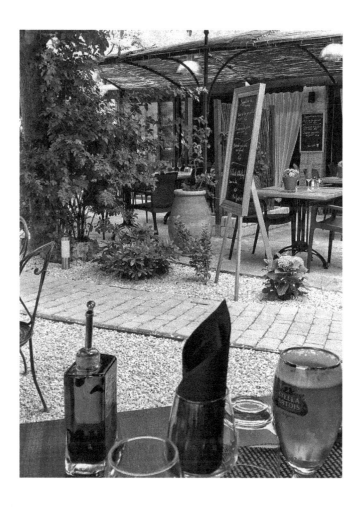

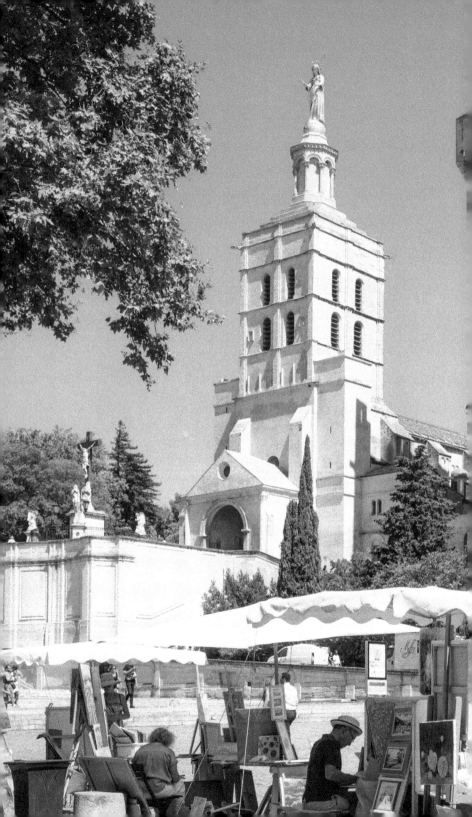

Visiting Avignon

Avignon, the city of the Popes, sits on the Rhône River, deep in the heart of Provence. Beginning with Pope Clement V in 1309, Avignon was the seat of power of the Catholic Church for more than seventy-five years. The Papal Palace, constructed of pale-yellow limestone, built to reflect the power and wealth of the pope and the papal court, dominates the city, and is now a World Heritage site. It is considered to be the finest example of Gothic architecture in all of Europe. Only two minutes from the Papal Palace visitors can enter another building of soft yellow limestone, this one constructed in the fourteenth century. Once a cardinal's palace, it is now La Mirande Hotel Restaurant. Hidden on a small *ruelle* (narrow street), it is a perfect place to pause for an elegant lunch or dinner of *Provençal* specialties in the beautifully restored dining room; tea, served daily, on the glass enclosed terrace; or depending on the weather, in the cozy bar. The city center of Avignon is small, and the Pont d'Avignon, made famous by the children's song of the same name, is only a short walk from the Papal Palace. During the Middle Ages, pilgrims on their way to Spain

and elsewhere had to pay a toll to cross. Today the bridge's stone arches reach less than halfway across the wide Rhône River.

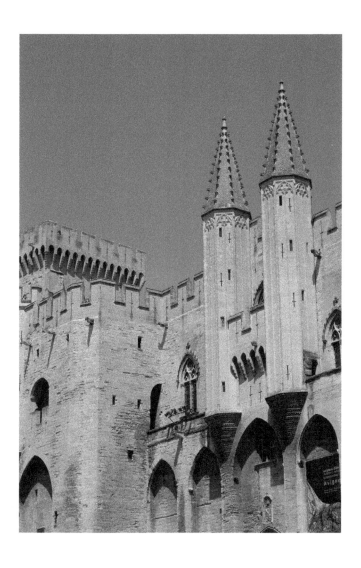

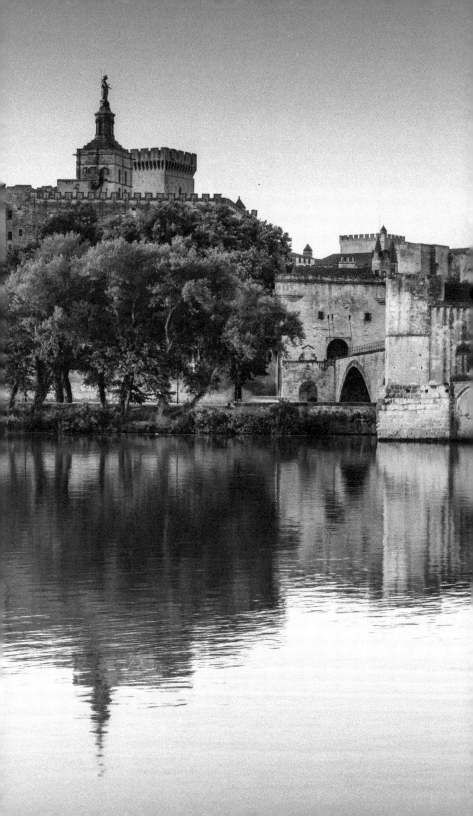

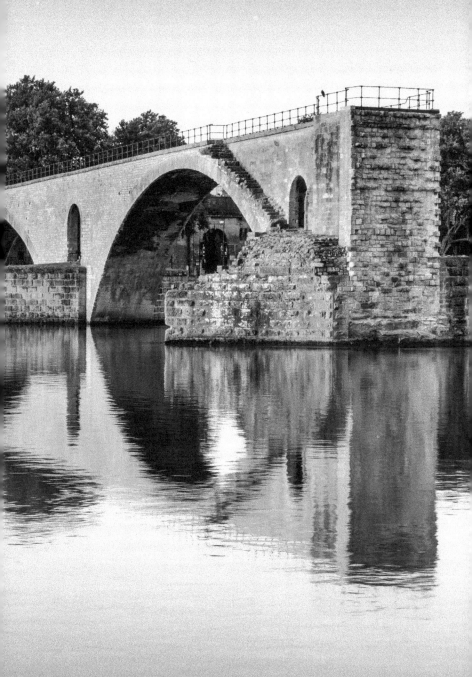

Driving Tips

Driving in France can be tricky. Here are a few tips that may help you have a smooth journey.

The first thing to note is that France has tolls on their *Autoroutes*, which are large, multilane highways. There are a few ways to pay the tolls, and it is important to understand that before you queue at the toll booth, discover you're in the wrong line, and stressfully hold up traffic, while you ring for help from an attendant.

Additional lanes will be added as you approach the toll booths, and the type of booth will be indicated by the sign above it. If it is a booth that will take coins, there will be an image of coins above the booth. If the booth requires you to have a prepaid card, there will be a circle with a red line through it to indicate that people who do not have the prepaid card cannot use that toll booth. The other booths are for people who want to pay by credit card. They will be indicated by

a lower case "t" and show an image of a card with a magnetic strip.

Toll booths near larger cities, for those traveling only a relatively short distance, are the ones set up to allow the driver to simply throw the appropriate number of coins into a basket. The amount due will show, but it has to be paid in coins, so be sure to have a lot of coins at the ready.

Once you are out of range of the throw-in-the-coins booths, the tolls work on a ticket system. When you enter the *Autoroute*, look for the toll booths that have only a lower case "t" above them. They are usually toward the right side of the line of booths. All you have to do is take a ticket at these booths. Keep this ticket handy. You will need it to exit the *Autoroute*! That ticket indicates where you have entered and will register how much you owe once you exit or have traveled far enough that you have to pay for the segment you've just driven. When you get to the toll booths that require payment, enter your ticket into the left-hand slot and then put your credit card into the slot next to it. It will then charge you the appropriate amount, spit your card

back, and raise the arm, allowing you to pass. Note that you should slide your card chip end first into the slot.

If you get into a pickle, there is a call button where you can talk to someone. If you don't speak French, at least begin with a "*Bonjour*" and say "*Je suis désolé,*" which means you're sorry. They may take pity on you and simply raise the arm if you're in the incorrect line.

When driving on smaller roads, note that the French generally drive along at a speedy clip and have no problem driving close behind you. Don't take it as an act of aggression, they simply leave less space between cars than drivers in the United States. That said, if you have a car behind you, and can turn out when a safe spot presents itself, do so, because it's frustrating to be behind a slower driver on narrow, two-way roads.

If you are using GPS, note that it is difficult to spot street signs, which are located on the sides of buildings, but that the GPS will most likely also indicate that you should continue going toward a specific town, which are well marked with white arrows and easier to spot than street signs. Provence uses roundabouts extensively, so if you

don't spot the direction you should be heading toward when you enter the roundabout, simply go around another time until you spot the sign you're looking for.

Acknowledgements

As with other books of this nature, it would be difficult for any of it to come to fruition without the generosity of others. In particular, I would like to thank my friends and neighbors in Provence who, over the more than fifty years I have known many of them, continue to share their lives, insights, and secret places with me. Since this book is a reflection of that half century, the list of people is long, and some of them are now gone, but their spirit and what they taught, shared, and showed me endures.

In particular, in realizing this book, I'd like to thank the Fine family of Moustiers-Sainte-Marie, whom I first met when I moved to rural Provence with my first husband, Donald, and our toddler daughter in 1969. Denys and Georgina and their children Vania and Johann, and Denys' brother Michael, have been a part of my life and my children's lives ever since. For this book, the Fines showed the photography team around their village, introduced them to shops and shop owners,

secured permission for photos, and shared the story of their village.

Director Sarah Cheleine and Chef Fr Garnier and the staff of the Bastide de Moustiers were incredibly gracious, allowing the photo team to photograph cheese platters, fish, and cherries in the kitchen and to roam and photograph the property at will, while keeping us supplied with coffee and treats.

Lisa McGuinness is responsible for virtually all of the photos, and she did an amazing job of capturing the villages, country roads, and cities of Provence in the images that enrich this book. It was wonderful to have Cheryl Duncan as the photo assistant, and Lisa especially wants to thank her for her fine navigation skills and general help. A special thank you to Rose Wright for being part of the photography team.

Thank you to my husband, Jim Schrupp, who traveled with me to many of the places celebrated in this book, and who helped me, once again to put my thoughts into words.

About the Author

Georgeanne Brennan is the recipient of both a James Beard Award and an International Association of Culinary Professionals Award. She has authored and coauthored many cooking and gardening books. She is the founder of La Vie Rustic (lavierustic.com), a line of garden and kitchen products for sustainable living in the French style. She divides her time between her home in Provence and her small farm in Northern California.

yellow pear 🍐 press

Yellow Pear Press, established in 2015, publishes inspiring, charming, clever, distinctive, playful, imaginative, beautifully designed lifestyle books, cookbooks, literary fiction, notecards, and journals with a certain *joie de vivre* in both content and style. Yellow Pear Press books have been honored by the Independent Publisher Book (IPPY) Awards, National Indie Excellence Awards, Independent Press Awards, and International Book Awards. Reviews of our titles have appeared in Kirkus Reviews, Foreword Reviews, Booklist, Midwest Book Review, San Francisco Chronicle, and New York Journal of Books, among others. Yellow Pear Press joined forces with Mango Publishing in 2020, with the vision to continue publishing clever and innovative books. The fact that they're both named after fruit is a total coincidence.

We love hearing from our readers, so please stay in touch with us and follow us at:

Facebook: Mango Publishing
Twitter: @MangoPublishing
Instagram: @MangoPublishing
LinkedIn: Mango Publishing
Pinterest: Mango Publishing
Newsletter: mangopublishinggroup.com/newsletter